GILDING

APPROACHES TO TREATMENT

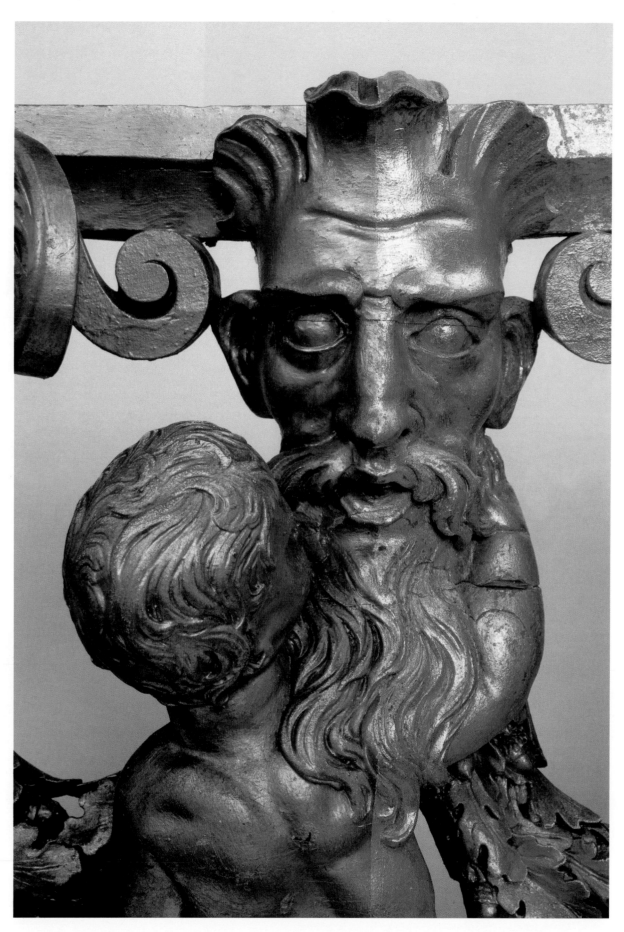

Detail of the mask of the River God from the right hand Chiswick House table during dry stripping of the additional layers to reveal the original gilding. © ENGLISH HERITAGE PHOTO LIBRARY/JONATHAN BAILEY

GILDING

APPROACHES TO TREATMENT

A joint conference of English Heritage and the United Kingdom Institute for Conservation 27–28 September 2000

UKIC Gilding Section

ENGLISH HERITAGE

JAMES
X
JAMES

Published by James & James (Science Publishers) Ltd,
35-37 William Road,
London NW1 3ER, UK

A catalogue record for this book is available from the British Library
ISBN 1 902916 25 5

Designed and Typeset by Hardlines, Charlbury, Oxford.
Printed in the UK by Stones the Printers
Front cover © English Heritage photo library/Johnathan Bailey

Contents

Foreword

The 'Gilding: Approaches to Treatment' conference on 28 September 2000 was a collaborative event organized by the Gilding Section of the United Kingdom Institute for Conservation of Historic and Artistic Works (UKIC) and English Heritage. The UKIC Gilding Section committee was interested in addressing the different techniques and attitudes involved in treating gilding on different materials. At the same time, English Heritage had just completed the conservation of the Chiswick House tables, and returned them to public display, and was keen to promote the issues raised during the eighteen months spent working on them. Largely funded by the Heritage Lottery Fund, the Chiswick House tables project was a landmark event that notably raised the professional standard of gilding conservation project work at English Heritage.

The aim of the conference was to achieve a greater understanding of the reasons and variations in the approaches to the treatment of gilded materials. Gilding is found on a wide range of materials right across the spectrum of the visual arts, and the conference attracted speakers from the conservation fields of archaeology, metalwork, architecture, sculpture, paintings, frames and furniture.

It is thanks to English Heritage that post-prints of the conference papers have been published, increasing access to the information and disseminating the knowledge gained from these experiences to a wider range of conservators and custodians of gilded objects. The following papers present not only technical details of conservation projects, but also discuss the long and complicated decision-making processes, during which questions such as the most appropriate materials to use, and the extent of conservator intervention, are considered. Collection management issues are also addressed, including the planning of conservation and care for large numbers of objects belonging to a single organization. The keynote paper by Julius Bryant introduces a curatorial perspective that invites us to recognise the social values that can be involved when deciding upon the final appearance of conserved gilded objects.

Together, the papers represent current thinking and practice from a large number of the UK's national institutions and leading conservation specialists. In focusing on the approaches to gilding treatments, it is hoped that an increased understanding of the shared issues in gilding conservation will be gained across very different disciplines, and lead to a consensus regarding the ethics of gilding conservation in its many contexts.

Lastly, it should be noted that it has not been UKIC or EH policy with these papers to dictate policy or practice. The views expressed are those of the individual authors.

Victoria Boyer and Ben Pearce
UKIC Gilding Section Committee

Acknowledgements

The reception at Chiswick House on 27 September 2000, and the conference at the Scientific Societies Lecture Theatre on 28 September 2000, were jointly hosted by the UKIC Gilding Section and English Heritage. The organization of both events involved many people. Special thanks are due to several individuals for their role in ensuring the realization and success of both events. We are very grateful to Amber Xavier-Rowe, Head of Collections Conservation at English Heritage, for committing English Heritage sponsorship. The smooth running of both events was due to Dee Lauder, Collections Assistant at English Heritage, and her unstinting work in coordinating the reception and conference. The UKIC Gilding Section Committee played a substantial role in organizing the speakers. We should like to acknowledge in particular Vicki Boyer and Ben Pearce, who took on a large share of the administrative workload. We are especially grateful to Diane Copley, UKIC Office Administrator, for her enormous contribution to the administration and ticket sales for both events. Thanks also to Judy Wetherall for organizing the conference packs and to Leslie Charteris for coordinating the poster displays. Last but not least, we are indebted to Jeremy Noel-Tod, our consultant editor, for editing the papers of twelve speakers from different fields into a coherent body of text for publication.

Michael Parfett
Chairman, UKIC Gilding Section

The Midas temptation: Conserving gilded furniture at Chiswick House and Kenwood

Julius Bryant

Director of Museums and Collections
English Heritage, 23 Savile Row, London, W1S 2ET
tel: 020 7973 3487 fax: 020 7973 3209 e-mail: julius.bryant@english-heritage.org.uk

Abstract

At English Heritage's historic house museums the traditions and philosophies of building conservation meet those of fine art conservation. As gilding is used on almost every medium, it is a key with which to examine the interrelationship between these approaches and attitudes. Inconsistencies in a room can be eliminated by imposing a single approach across all media, or they can be retained and explained as opportunities to engage visitors in the different conservation traditions, and the thinking behind the choices available. This paper explores the 'baggage' of associations that influence 'good taste'. Gilding is a good example, for in Britain it is often associated with deception, imitation, affectation, superficiality, greed, ostentation and excess, social value-judgments that can influence conservation treatments, despite claims in conservation policies of scientific disinterest and open-mindedness.

Key words

Chiswick, Kenwood, Burlington, gilding, conservation, furniture, English Heritage, curator

The restoration of English Heritage's own historic house museums has created frontiers where the traditions and philosophies of building conservation meet those of fine art conservation, on a daily basis, and on public display. As gilding is used on almost every medium, from architectural ornament to paintings, furniture and the decorative arts, it is a key with which to examine the interrelationship between these approaches and attitudes.

Gilded furniture and decoration in English Heritage's historic house museums vividly illustrate the variety of approaches, often within the same house, the same room, and even the same suite of furniture. This variety, or inconsistency, is of course partly due to the different media employed, the condition, setting, status, and individual provenance of objects, and the varying resources available for conservation projects. But it is also due to the expectations of visitors and the presentation values of curators and conservators. This paper explores the attitudes and values that can influence choices about the final appearance of conserved objects.

English Heritage's decision to collaborate with UKIC in organising the conference, 'Gilding: Approaches

to Treatment', coincided with the completion of its most ambitious gilding conservation project. In July 1996 a pair of tables made for Richard Boyle, third Earl of Burlington (1694–1753), and creator of Chiswick House, was purchased by English Heritage at auction for £840,000. Among the many grants received, the most substantial came from the Heritage Lottery Fund (HLF), who subsequently agreed to provide a further £52,000 to cover the cost of conservation and display (Fig 1). The tables first arrived in Lord Burlington's villa at Chiswick around 1730, were removed in 1892 and finally returned to their historic positions, following conservation, in October 1999 (Fig 2). The grant application promised the HLF that this would be an exemplary project, involving a variety of methods of technical analysis and decision-making that had not been used for furniture conservation before. To date, four articles have been published, covering the history of the tables and their conservation [1]. The project conservator, Dave Gribbin, provides his technical report at the end of this volume.

However, the project also raised an important issue. Despite the wealth of technical guidance available to conservators, particularly in the form of case studies, the

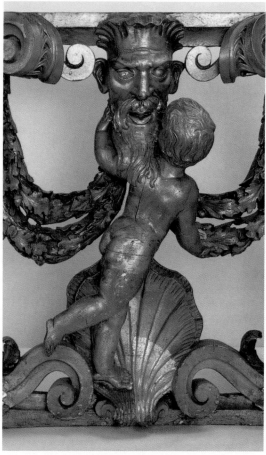

Figure 1 Detail of one of the Chiswick tables, probably made by G.B. Guelfi (1690/1–after 1734) around 1720, during dry stripping back to its original gilding. © English Heritage Photographic Library

need remains to explore the values that influence the aesthetic choices made by the curator as client, particularly when it comes to the degree of retouching and 'finish' required, at that vital stage when conservation creeps towards restoration [2].

Despite the dazzling array of technologies involved (including analysis by X-radiography, dendrochronology, photogrammetry, and a scanning electron microscope), the wealth of data assembled, and the use of a new cost/benefit appraisal model, the ultimate decision regarding the 'finish' of the Chiswick tables did not rest on rational analysis alone. Aesthetic criteria inevitably involve personal 'taste' and a vocabulary of subjective terms such as 'legibility', 'the integrity of the object' and 'the character of the house'. The systematic scientific data surrounds what is, fundamentally, the weak link of 'good taste'. The amount of analysis provides a broad basis for decisions, and a necessary sense of reassurance to funding bodies, accounting officers and, indeed, the museum visitor. But ultimately it is outweighed by the contribution of the curator and conservator, and by faith in one's instinctive visual judgement. Given the right people, this weak link in the rational, scientific process can be what actually holds a project together. However, it can also lead to inconsistent and irrational attitudes towards finish. This is particularly evident with the gilding of furniture and historic interiors, where a variety of approaches to finish can end up in the same room.

We still need to unpack that moment of truth, when the conservator (armed with volumes of condition reports, treatment options and methodology statements) looks to the curator, as budget-holder and client, to

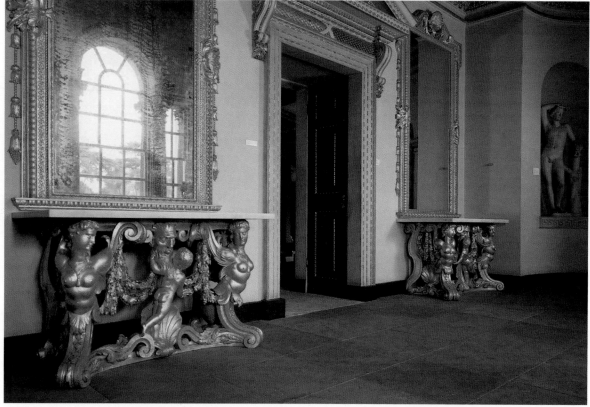

Figure 2 The Chiswick tables reinstated in the Gallery at Chiswick House. © English Heritage Photographic Library

decide (with the conservator's advice) how the object should ultimately look. This is, of course, a much wider issue affecting the conservation of all media, not just gilding. But gilding is the ideal material through which to address it, as gilding is used on every variety of historic artefact, from icons to window frames, and so brings together the traditional schools of conservation theory, from art through to archaeology and architecture. It is also a medium with a distinct set of associated values that influence 'aesthetic' decisions.

Essentially there are three schools of thought affecting decisions over finish, any one of which may take priority depending on the artefact in question. Most popular is the 'former glory' school, which seeks to achieve the closest possible approximation to the object's original physical appearance (even though ultimately we are never able to see an object as it was originally perceived). This is usually chosen for objects now regarded as works of art – that is, those that are judged today as having some timeless aesthetic significance that can be credited to a named maker and/or client. The second option is the social history approach, which values and stabilizes all signs of wear and tear and accretions over time as evidence of generations of users, and regards the object as a record of tastes and attitudes. The third option favours the physical context, where the setting takes priority and individual objects need to play their assigned roles, whether as stars or chorus line, on the museum stage.

In practice these criteria compete. For example, the great cultural significance of the Chiswick tables lies not so much in them being an essential part of the interior architecture, in their status as the most important pieces of furniture at Chiswick in their own right. They pre-date William Kent's more familiar architectural translation of Italian Baroque furniture, developed for English Palladian interiors from 1725. They were probably designed by Lord Burlington himself to support a pair of specimen marble slabs he bought in Genoa in 1719. They may have been carved by the sculptor Giovanni Battista Guelfi (1690/1– after 1734) around 1721. They would have been made for Burlington's Jacobean family house at Chiswick and then moved into their present positions in the villa around 1730. In the history of furniture they are the key example of the evolution of English Palladian furniture from its Italian Baroque sources. A claim could even be made for them today as works of sculpture.

Given such cultural significance and aesthetic status, why, after deciding to reveal the original gilding, did we feel the need to retain some old marks of wear and tear in addition to leaving one end undisturbed as a reference point for the later layers of gilding? We could have decided that their condition on purchase carried the whole physical history of their successive ownership, and should have been preserved in its entirety. Yet the dull greenish bronze tone from the pigmented shellac varnish, the misshapen replacement oak leaves and the metal brackets of botched old repairs were so repugnant that retaining the tables in such a state would have

undermined the credibility of our claims when fundraising to buy them. If their physical setting, Chiswick House, is the real priority for English Heritage (which only collects to display on site) how can the Gallery there determine the conservation approach, when its décor (and much of its fabric) still dates from the 1950s restoration, and there is no funded scheme to restore it? Indeed, their earliest setting is lost if it really was Burlington's old Jacobean family home.

With competing criteria influencing the degree of finish, personal taste inevitably provides a short cut, pushed along by a baggage trolley of associated values. For example, some wear and tear may justifiably be retained as evidence of age and authenticity but, even in the best British country houses, it can also serve to imply the 'authenticity' of the owners – 'old money' with too many other commitments to bother with repairs, happy to look 'shabby chic'. For waxed furniture, particularly 'old oak', we appreciate the generations of polish and grease as mellow 'patina', yet for gilding we tend to remove later layers, but stop short of showing gilding 'as new'. Resisting the Midas temptation to regild over repairs, in Britain we tend to cling to some evidence of age, or resort to distressing new work, toning it down to look old and thereby creating a finish that, being a hybrid, is quite new. In some people's eyes, new, unbroken gilding in particular (Fig 3) suffers from connotations such as 'flashy', 'vulgar' and even 'kitsch'. Before attempting to unpack this baggage, which conservators may not always recognize behind their clients' good taste, the scale of the challenge may be illustrated through the variety of approaches to gilding now evident at two English Heritage houses.

One way to characterize English Heritage's houses is to say that they are relatively empty and being refurnished. As the Government's official adviser on the historic environment, empowered to act as the nation's final 'safety net' for properties at risk, English Heritage (the Historic Buildings and Monuments Commission) has taken on six houses since it was founded in 1984, only one of which – Brodsworth Hall – retained its historic contents. Due to the availability of outside funding for acquisitions and opportunities to collect lost contents, the campaign to refurnish these houses has run ahead of the restoration of their interior decoration. As objects return to the houses from private collections, after a century or more of building up their international provenances, they are reunited in settings they must find unrecognizable. Were they to enter major museums as individual specimens on pedestals they might expect to be sent off to be stripped of their travel clothes and return as works of art. But in a house context, where the prevailing conservation philosophy comes from architectural history, the words 'conserve as found', 'minimal intervention' and 'reversibility' echo around the emptied rooms, encouraging curators to leave their new arrivals 'as found'. It must be admitted that a further incentive for this approach is that grants for acquisitions do not cover conservation costs (with the exception of the HLF grant on this occasion).

Figure 3 Magazine advertisement for the Silik Range of modern Italian gilded furniture, 1999. © Casa D'Italia (Imports) Ltd

The Chiswick tables are the eleventh and twelfth pieces of original furniture to return to the house since 1990, and the first to be conserved. In the 1950s radical architectural restoration clipped Burlington's villa of its late eighteenth-century wings and committed future generations to its presentation 'as new' – that is, as if in the 1730s. However, it did so without reinstating the lavish gilding, velvet and damask hangings that Burlington created. The result is a dark patchwork of approaches to gilding, a standing archive of later layers and repairs, in which the tables, freshly stripped, now shine out. They show how the whole *piano nobile* must once have dazzled as an Italianate fantasy and might again, if we can overcome not only the need for funds

but also the British national preference for sobriety and understatement. When it comes to questions of 'etiquette' and 'taste' we expect our furniture to be brown, and prefer our gilding distressed or in the shadows, unlike the Italianate taste of Burlington.

A similar dilemma is growing at Kenwood, the north London villa remodelled by Robert Adam (1728–92) for William Murray, first Earl of Mansfield (1705–93) from 1764 to 1779. Just as Chiswick was emptied of its furniture by 1892, so Kenwood lost its contents at auction in 1922, including furniture designed by Adam. Some has returned in recent years, while a collection of furniture designed by Adam for other houses (notably Moor Park, Croome Court, Bowood and 20 St James's Square) has also been formed.

Three furniture gilding conservation projects have been undertaken at Kenwood, each quite different in approach and results. They illustrate how, in the absence of fully restored physical settings, aesthetic judgements about the degree of finish are influenced by subjective values as much as by historical and technical criteria. The Moor Park suite was designed by Adam to stand in a vast painted saloon, decorated by James Thornhill (1675–1734), which survives today in a golf club. The suite is unique in British furniture in combining gilding with plain blue leather upholstery, rather than damask (Fig 4). By the time that most of the suite had been reunited at Kenwood (from Yorkshire, Ireland and the White House, Washington, DC) the gesso had shattered to such an extent as to prompt total stripping and regilding. At first, the 'as new' total finish attracted criticism and the curators considered toning it down with lacquer so that it would not appear too bright. But, following recent reupholstery of the sofas as part of the major refurbishment at Kenwood, they now add a welcome sparkle to the newly curtained and carpeted interiors in which the gilding no longer seems distracting (Fig 5).

A pair of pier tables and a pair of mirrors, attributed to William France (*c.* 1734–73), which were sold from Kenwood in 1922, returned in 1994 from Luton Hoo and were conserved by Carvers and Gilders. Extensive original oil gilding was found to survive and was revealed with minimal retouching. They were displayed so that they would not pose a challenge to the Old Master paintings of the Iveagh Bequest, which have taken priority at Kenwood since it opened as a gallery in 1928.

No such challenge is posed by the torchères designed by Adam for the London town house of Sir Watkin Williams-Wynne (1748–89) in 1773. When purchased in 1990, off a conservator's bench, they were already well on their way to being totally stripped back, though only in order to reveal traces of their original water gilding (Fig 6). Stripping by the dealer's conservator certainly revealed the quality of the carving, but there is possibly something of the 'emperor's new clothes' about savouring fragments of original gilding, given that the now brown torchères were meant to be seen as objects of gold.

An alternative route through this question of taste is to explore the meaning of gilding beyond furniture conservation. The wider social values that come into play are more obvious in English literature. In Renaissance Italy gilding had spiritual associations and was used in paintings to symbolize divinity and religious devotion, but in Britain by the sixteenth century the word carried very different moral values, as if the medium were itself deceptive, a subsitute for solid gold. *The Oxford English Dictionary* gives as its fifth meaning of 'gild', 'To give a specious lustre'. Noting that the term was in use by 1596 it quotes Shakespeare: 'This grand Liquor that hath gilded 'em'. Under 'gilded' the dictionary cites gilded youth or *jeunesse dorée* as 'fashionable young men of wealthy families'. In *Roget's Thesaurus* the word 'gilt' may be found between 'richness' and 'ostentation' – while the word 'gild' comes between 'plate' and 'lay it on thick'.

Shakespeare provides five more examples. In *Henry IV: Part I* Prince Hal remarks:

> For my part, if a lie may do thee grace,
> I'll gild it with the happiest terms I have.

Lady Macbeth plans to 'gild the faces of the grooms' with the murdered king's blood, punning 'For it must seem their guilt'. In *King John*, Lord Salisbury observes, apparently coining a phrase:

> To gild refinèd gold, to paint the lily, …
> Is wasteful and ridiculous excess.

In *Richard II* the Duke of Norfolk laments 'Men are but gilded loam or painted clay' and in *The Merchant of Venice* we first find the saying:

> All that glisters is not gold,
> Gilded tombs do worms infold.

Figure 4 Detail of a chair from the Moor Park suite, designed by Robert Adam (1728–92) and made by James Lawson (fl. 1768–78) c. 1764 now at Kenwood, showing new gilding. © English Heritage Photographic Library

Here Shakespeare adapts an adage from the thirteenth century that may also lie behind Chaucer's warning that 'Gilt spurs do not make the knight'.

Deception, falsehood, fashion, extravagance are combined with even more negative associations including murder, death and decay. Gilding has a long history

Figure 5 Sofas from the Moor Park suite in the newly decorated Music Room at Kenwood. © Tim Imrie-Tate/Country Life Picture Library

as being a matter for suspicion. Little wonder then that in 1774 Lord Melbourne wrote to Sir William Chambers over the decoration of his house in Piccadilly:

> I am more and more averse to admit any gilding whatever even in the furniture, in my opinion the Elegance of that room is from the lightness of well disposed well executed Ornaments; vastly preferable to any load of gilding [3].

In nineteenth-century Britain the idea of gilding as a flashy foreign fashion was reinforced by the 'tous-les-Louis' style of interiors in the French taste. In America the century closed with an era of dubious extravagance and conspicuous consumption by tycoons, many of whom purchased the gilded furniture that has since been repatriated to British house museums. The era was dubbed 'The Gilded Age', satirically echoing 'The Golden Age' of early seventeenth-century Holland. Meanwhile, the British wrote the history of the era's furniture in terms of three brown 'Ages': old oak, walnut and mahogany. The richer the so-called patina of the age (of dirt, varnish and sweat) the better the brown wood looks. In 1915 the idea of stripping the gilding off the Albert Memorial, supposedly to make it less of a target for Zeppelin bombardment, was put to King George V. He agreed as it would make the memorial 'so much less ugly'. In post-war Britain, James Bond's arch-enemy, Goldfinger, is a latter-day Midas, who

murders 007's girlfriend by almost literally gilding his lily – he covers her with gold paint.

In short, when it comes to choosing gilding treatments in Britain curators and conservators have to wade through a sea of negative associations. No wonder that clients stop short of total retouching and shy away from reinstating the full glory of unbroken gilding, overlooking subtleties of colour, shading, texturing and burnishing that can enhance the details of carved gesso and wood. Instead, we retain traces of wear as evidence of an object's age and authenticity. In resisting the Midas temptation we run the risk of creating a new aesthetic of worn gilding alongside new upholstery and hangings. This combination is symptomatic of a wider inconsistency in the traditions of art and architectural conservation, and says more about our own taste today than about the past.

Notes

1. Bryant J., 'The Chiswick Tables' *National Art Collections Fund Review* 1996, 108–9; Cassar M., ' How English Heritage Decided on an Appropriate Treatment for the Chiswick Tables' in *Cost/benefit Appraisals for Collections Care* (Museum and Galleries Commission, 1998) 17–21; Drysdale L. and Rowe A., 'The Impact of Context – Collections Conservation in English Heritage' in *Site Effects: The Impact of Location on Conservation Treatments* (S.S.C.R., 1998) 77–82; Drysdale L., 'Conservation of the Chiswick House Tables' *Collections Review* (English Heritage, 1999) II 73–76.

2. See Zimmerman P. D., 'Priorities in Gilding Conservation from a Curatorial Perspective' in *Gilded Furniture: Conservation and History* (ed.) Bigelow D., (Philadelphia, 1991) 231–238, particularly 233: 'The only time this additional treatment is useful is … when the repairs interfere significantly with the aesthetic appreciation of the object – a value judgement for the curator'.

3. Quoted in Gregory M., 'A Review of Gilding Techniques. Original Source Material about Picture Frames' in *Gilded Furniture* (op. cit.) 109–118, 115.

Biography

Julius Bryant is Director of Museums and Collections at English Heritage where he has specialized in the restoration and refurnishing of historic houses as museums. He was appointed Assistant Curator of the Iveagh Bequest, Kenwood (GLC), in 1983 and has had professional responsibility for English Heritage collections and curators since 1990.

A Fellow of the Society of Antiquaries and a former Council Member of the Furniture History Society, he trained as an art historian at University College, London, the Courtauld Institute of Art and Yale. He is an elected Board member of DEMHIST, the ICOM committee for historic house museums.

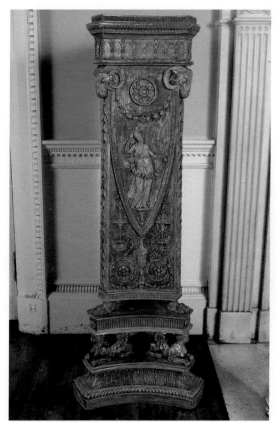

Figure 6 Torchère, c. 1773, one of a pair designed by Adam for 20 St James's Square, London, purchased for Kenwood, following stripping back to original gilding. © English Heritage Photographic Library

The conservation of gilded archaeological artefacts: Its effects and implications

Glynis Edwards

Head of Archaeological Conservation, Centre for Archaeology
English Heritage, Fort Cumberland, Eastney, Portsmouth, Hampshire, PO4 9LD
tel: 02392 856793 fax: 02392 856701 e-mail: glynis.edwards@english-heritage.org.uk

Abstract

In the 1960s and 1970s interventive methods were used to clean gilded archaeological artefacts. These cleaning methods have had effects on later scientific study. During the 1980s the approach to archaeological conservation became much more selective. Artefacts were viewed in the context of whole projects and ongoing research for publication, rather than as objects in isolation. By the 1990s the term 'cleaning' was replaced by 'investigation'. The approach adopted was to find out the details of construction and technology by examination, rather than totally to remove surface corrosion products. The aim is to leave evidence for future study as new techniques are developed and new questions asked.

Key words

Brooches, burials, costume, mercury gilding, metalwork, textile, tool marks

This paper examines interventive methods used in the conservation of gilded archaeological artefacts in the 1970s and 1980s and discusses how we might deal with such material today. The development of archaeological conservation at the Ancient Monuments Laboratory (AML) and the move away from more active treatments of artefacts to minimum intervention resulted from the way in which conservation was organized in the institution.

For many years part of the conservation branch of the AML had no direct museum role. Material worked on came from excavations funded by English Heritage and its predecessors, the ultimate destination of this material being museums around England. This enabled the team to become more closely involved in the archaeological process, concentrating on obtaining information from artefacts for the archaeological reports. The techniques of investigative conservation were gradually developed to produce the maximum amount of information with the minimum of intervention. With the production of the second edition of *Management of Archaeological Projects* (English Heritage 1991) conservation's role in the archaeological process was defined. In the early 1990s, as a reflection of the large amount of historical material in the English Heritage collections, the branch was reorganized into two teams: Archaeological Conservation and Coll-

ections Conservation. The Archaeological team took on the responsibility for conservation of the archaeological collections, and thereby assumed a museum role in addition to its investigative one. However, work carried out in the years before this formed an important part in the development of archaeological conservation techniques.

Fire-gilding

Anglo-Saxon brooches were often decorated with gold and other materials (Leigh 1990). They were generally cast, often with chip-carved decoration, and gilding was applied either as leaf, or with a method employing mercury ('fire-gilding'). This technique involved applying an amalgam of gold and mercury to the surface of a silver or copper alloy artefact and then heating it to drive off the mercury, leaving the gold bonded to the surface. Analysis of gilded artefacts often detects mercury, indicating that they were treated in this way. Evidence for this technique has been discovered at Southampton (Hinton 1996, 80–82). A flat stone with a depression in one side was found to have deposits in its surface of gold-like flecks, and black and red powder. On analysis this was found to consist of gold and mercury, suggesting that the stone had been used as a mortar for preparing the amalgam.

Reconstruction

Burials from pagan Saxon cemeteries (where the dead were interred fully clothed with their equipment) provide a wealth of evidence beyond the metal artefacts. Organic material such as textiles from clothing can be preserved by the action of the corroding metals (Edwards 1989; Watson and Edwards 1990). Care taken on excavation when recording the position of the artefacts in the ground, and in the laboratory when recording the position of organic materials on them, can lead to the reconstruction of organic artefacts from what may be minute scraps of evidence. This clearly demonstrates the fact that it is not lone 'things' that are being dug up, but people (Wheeler 1966, 13). It is important not to consider objects simply in isolation, but also to take account of what they can tell us about their sites.

A gilded, square-headed Jutlandic brooch from Grave 14 at Appledown, West Sussex (Down and Welch 1984; Down and Welch 1990, 95–96), had textile preserved on the back, due to the corrosion of the iron pin. In the corrosion on the front of the brooch (Fig 1) pupae cases were preserved, indicating that there was a gap between death and burial when flies laid eggs on the corpse (Janaway 1987). Two cast saucer brooches in Grave 10 from the same cemetery (Down and Welch 1990, 96–97) were found positioned on the shoulders, indicating that the occupant was wearing a tubular gown fastened by this means (Owen-Crocker 1986, 28–29). These brooches also had textile preserved on the back by the corrosion of the iron pins, and pupae cases on the front. A wing case of an adult fly was found on the surface of one of the brooches after removal of the corrosion products, and this was left in position. Two cast saucer brooches were also found in Grave 14: the textile remains and the position of the brooches indicated a different style of costume. The square-headed brooch was fastening a cloak on the right shoulder, while the saucer brooches were fastened lower down to a Frankish-style gown with tailored shoulders (Owen-Crocker 1986, 60–61).

Examination

X-radiographs were taken of the brooches before starting work on them (Fig 2) and the decoration showed up

Figure 1 Jutlandic brooch from Appledown after excavation. © Crown Copyright

Figure 2 X-radiograph of the Jutlandic brooch showing details hidden by corrosion. © English Heritage

clearly. The corrosion on all the brooches was heavy and it was decided to remove this mechanically, as there may have been a risk of redepositing copper through the use of chemicals. The brooches could certainly not be soaked in chemicals, as this would remove the textile evidence. Using an engraving tool or vibrotool fitted with a needle (Cronyn 1995, 64–65), it was possible to detach the corrosion quite cleanly from the gold surface underneath. A scalpel was also used in this process. This was carried out under low-power binocular magnification. If this method had not been employed the fly's wing case would have probably been lost, given that it was in fact formed of copper corrosion. To complete the cleaning a 5 per cent solution of formic acid was used (Plenderleith and Werner 1976, 217), applied with cotton-wool swabs. It was decided to leave the textile remains on the back of the brooches. In order to define details of the pins, X-radiographs of the catch plates and pin lugs were taken from the side. After conservation (Fig 3) the brooches were analyzed using the X-ray fluorescence spectrometer (XRF) and were found to have been mercury gilded – the square-headed brooch from Grave 14 being of base silver and the brooches from Grave 10 of copper alloy.

Another pair of gilded brooches was found in Grave 935 from Cemetery 2 at Mucking, Essex (Hirst and Clark, forthcoming). These were applied disc brooches (Evison 1978) and consisted of a back plate with catch plate and pin lug, and a thin front plate with *repoussé* ornament soldered to it. The textile preserved on these brooches again made it possible to reconstruct the costume. On the back, preserved by the iron pin, was a tablet braid and twill, indicating a tubular gown with tablet-braid edging. A large patch of textile preserved on the front of both brooches, which proved to be striped textile from a cloak, was fastened in the centre of the chest by an iron pin. Fortunately, the copper corrosion on the front of the brooches was soft, and it was possible to detach the textile without damage, leaving it available for later examination if required. As the front plates were very fragile they were backed with nylon gossamer fabric (attached with HMG cellulose nitrate adhesive) before cleaning. Initially, this was carried out mechanically – later, chemicals were used: dilute nitric acid on one brooch (Plenderleith and Werner 1976, 217) and formic acid on the other one. (Two conservators from different generations worked on these brooches, which might explain the different choices of chemical!) XRF analysis found no mercury, suggesting that the gold was applied as leaf.

Previous examinations

Other technological studies have been carried out on Anglo-Saxon brooches to investigate their manufacture. A study of punch marks has been made on material from Barrington (Malim and Hines 1998, 258–261) to see if the same punches were used on different items. The tool marks were examined using the scanning electron microscope (SEM), and the study of another group of brooches revealed some interesting additional tool marks (Rye 1994). A group of keystone garnet disc brooches from the Faversham area were held in the Ancient Monuments Laboratory, and these were examined using the SEM to see details of the manufacture. They had previously been examined for details of the gold foils behind the garnets (Avent and Leigh 1977), but this examination had used lower power magnification. These brooches were conserved in the 1960s: there are, unfortunately, no conservation records, but we can see that the conservators left their mark! Overlaying the marks made in manufacture there are marks left by a vibrotool, possibly with a fine punch used as a head instead of a needle (Fig 4), a scalpel (Fig 5) and even some glass bristles left in the side of one of the settings.

Textiles

Textiles such as braids and the edging of garments were sometimes themselves decorated with metal threads. Examples have been found from Roman contexts (Wild 1970, 131–132). The metal thread could be made in various ways – one example being a thin flat band wound round a core, often of silk (Wild 1970, 39) (Barker 1988). In the Anglo-Saxon period thin gold strips were used as surface brocading on braids (Hawkes and Crowfoot 1967).

A later example of this practice was discovered at the tomb of John Dygon, abbot of St Augustine's, Canterbury, who died in 1510 (Thorn 1981). Here, a fragment of

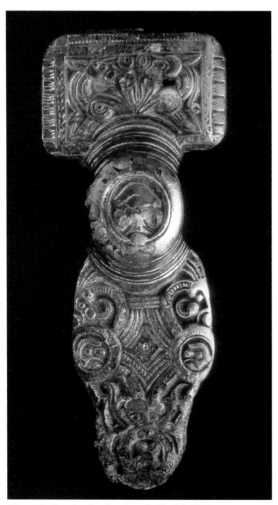

Figure 3 Brooch after cleaning. © English Heritage

Figure 4 Vibrotool marks in the gilding. © English Heritage

Figure 5 Scalpel marks overlying original tool marks.
© English Heritage

orphrey was decorated with metal and silk brocading. The X-radiograph (Fig 6) clearly shows the detail of the pattern. Very little intervention was undertaken as the fragment was deemed too fragile for washing, and the delicate silk threads would have absorbed any chemicals used to clean the metal threads. It was relaxed using humidity, and some gentle mechanical cleaning was carried out. After this it was subjected to textile analysis (by Elisabeth Crowfoot). Using the XRF the metal threads were identified: silver in the central portion and silver gilt on the border, both flat bands wound round a silk core. The bands for the silver gilt thread may have been formed by covering a block of silver with thin gold leaf, fusing it with heat and then beating it into a thin sheet, which would have been cut into strips (Barker 1988, 5).

Current approaches

The conservation detailed here was carried out in the 1970s and 1980s, when we used techniques that were much more intervenient than many we use today. However, we were always aware of the importance of ensuring that traces of other materials such as textile were fully recorded before conservation began. The delicate nature of the braid from St Augustine's Abbey ensured the minimum amount of active conservation was carried out, but the work on the brooches was a different matter. Today much more use is made of non-destructive means of examination, such as X-radiography, to reveal details hidden by corrosion. With the development of image enhancement even more information can be gleaned using this technique. Excavation has been described as destruction (Wheeler 1966 15),

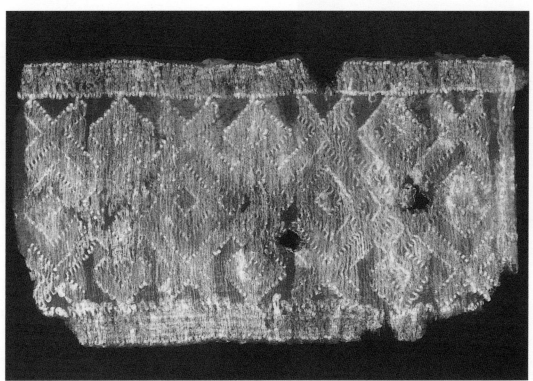

Figure 6 X-radiograph of tablet braid from St Augustine's Abbey showing pattern. © English Heritage

and removing corrosion from artefacts might possibly be regarded in the same way. We rarely use the term 'clean' these days, preferring instead the terms 'investigate' or 'removal of material', reminding ourselves that we may be removing evidence as well. With material being prepared for publication in excavation reports, such intervention only happens when details can be revealed in no other way. Museum display may be regarded as a valid reason for a certain amount of 'cleaning'. The brooches from Appledown are on display in Chichester Museum, but the examples from Mucking are in store.

Conclusion

There are other questions to be considered, too. Are we to regard the tool marks made in conservation as part of the history of the artefacts, along with the marks made in manufacture and the marks made during use? Should we store the needles and scalpel blades used to remove corrosion with the artefacts so that the signatures from these tools can be identified to assist any technological study? The importance of the recording of conservation methods, techniques and tools used is clear. Conserv-ators must always remember that conservation can have a considerable impact and is not necessarily the end point for artefacts – new studies may be initiated, and new techniques developed.

Acknowledgements

I am grateful to Dr Cath Mortimer who, when a member of the AML's Technology team, undertook the study of punchmarks on Anglo-Saxon brooches, and pointed me in the right direction to find the conservation 'horror' photographs. I would also like to thank Vince Griffin and Colin Slack for help in producing the illustrations and Dylan Cox and Karla Graham for comments on the paper.

Bibliography

Avent R. and Leigh D., 1977 'A Study of Cross-Hatched Gold Foils in Anglo-Saxon Jewellery' in *Medieval Archaeology* XX, 1–46.

Barker A. D., 1988 *Gold Lace and Embroidery*, Northern Society of Costume and Textiles, Publication 1.

Cronyn J. M., 1995 *The Elements of Archaeological Conservation*, London, Routledge.

Down A. and Welch M. G., 1984 'A Jutlandic square-headed brooch from Appledown, West Sussex' in *Antiquaries Journal* 64, 408–413.

Down A. and Welch M., 1990 *Chichester Excavations 7 Appledown and the Mardens*, Chichester District Council.

Edwards G., 1989 'Guidelines for dealing with material from sites where organic remains have been preserved by metal corrosion products' in (eds) Janaway R. and Scott B., *Evidence Preserved in Corrosion Products: New Fields in Artifact Studies*, UKIC Occasional Paper 8, 3–7.

English Heritage, 1991 *Management of Archaeological Projects.*

Evison V. I., 1978 'Early Anglo Saxon Applied Disc Brooches' in *Antiquaries Journal* 58, 260–278.

Hawkes S. C. and Crowfoot E., 1967 'Early Anglo-Saxon Gold Braids' in *Medieval Archaeology* XI, 42–86.

Hinton D. A., 1996 *The Gold Silver and Other Non-Ferrous Alloy Objects From Hamwic, and the Non-Ferrous Metalworking Evidence, Southampton Finds Volume 2*, Stroud, Alan Sutton Publishing,.

Hirst S. and Clark D., forthcoming 'The Anglo-Saxon Cemeteries at Mucking, Essex'.

Janaway R. C., 1987 'The preservation of organic materials in association with metal artefacts deposited in inhumation graves' in (eds) Boddington A., Garland A. M. and Janaway R. C., *Death, Decay and Reconstruction: Approaches to Archaeology and Forensic Science*, Manchester, 127–148.

Leigh D., 1990 'Aspects of Early Brooch Design and Production' in (ed.) Southworth E., *Anglo Saxon Cemeteries: A Reappraisal*, Stroud, Alan Sutton Publishing, 107–124.

Malim T. and Hines J., 1998 *The Anglo-Saxon Cemetery at Edix Hill (Barrington A), Cambridgeshire*, York, CBA Research Report 112.

Owen-Crocker G. R., 1986 *Dress in Anglo-Saxon England*, Manchester University Press.

Plenderleith H. J. and Werner A. E. A., 1976 *The Conservation of Antiquities and Works of Art*, Second Edition, London, Oxford University Press.

Thorn J. C., 1981 'The Burial of John Dygon, Abbot of St Augustine's, Canterbury' in (ed.) Detsicas A., *Collectanea Historica: Essays in Memory of Stuart Rigold*, Maidstone, Kent Archaeological Society, 74–84.

Rye S., 1994 'Investigation into the Technologies of Eight Keystone Garnet Disc Brooches From Maison Dieu Museum, Faversham, Kent', *Ancient Monuments Laboratory Report* 35/94.

Watson J. and Edwards G., 1990 'Conservation of Material from Anglo-Saxon Cemeteries' in (ed.) Southworth E., *Anglo Saxon Cemeteries: A Reappraisal*, Stroud, Alan Sutton Publishing, 97–106.

Wheeler M., 1966 *Archaeology From the Earth*, London, Penguin.

Wild J. P., 1970 *Textile Manufacture in the Northern Roman Provinces*, London, Cambridge University Press.

Materials and equipment
Analytical equipment currently in use at the Centre for Archaeology
SEM:
LEO Electron Microscopy Ltd, Clifton Road, Cambridge, CB1 3QH.
XRF:
EDAX UK, 3 Old Rope Walk, Haverhill, Suffolk, CB9 9DF.

Chemicals
(Hazard data sheets should be obtained from the suppliers and COSHH assessments carried out before use.)
Formic acid
Nitric acid:
Abinghurst, Unit 1, Ross Road Business Centre, Northampton, NN5 5AX.
R. and L. Slaughter, Units 11 and 12, Upminster Trading Estate, Warley Street, Upminster, Essex.
HMG cellulose nitrate adhesive:
Conservation Resources (UK) Ltd, Units 1, 2 and 4 Pony Road, Horspath Industrial Estate, Cowley, Oxfordshire, OX4 2RD.

Scalpels and blades:
Conservation Resources (UK) Ltd, Units 1, 2 and 4 Pony Road, Horspath Industrial Estate, Cowley, Oxfordshire, OX4 2RD.
Preservation Equipment Ltd, Vinces Road, Diss, Norfolk, IP22 4HQ.

Vibrotool (the needles used are standard crewel needles):
Customer Service Department, Burgess, Chadwicks, NY 13319, USA.
Watkins and Doncaster, PO Box 5, Cranbrook, Kent, TN18 5EZ.

Biography
After a BA (Hons) degree in Combined Studies (British Archaeology main) at the University of Leicester, Glynis Edwards studied for a Diploma in the Conservation of Archaeological Material at the Institute of Archaeology, London. As a student she undertook casual work at the Ancient Monuments Laboratory, DoE, and after qualifying in 1974 she was appointed Conservation Officer. She is now Head of Archaeological Conservation at English Heritage's Centre for Archaeology (formed by the co-location of the AML and the Central Archaeology Service at Fort Cumberland). She is a member of the Early Textiles Study Group, the Archaeological Leather Group, and is currently a committee member of the UKIC Archaeology Section. She is an Accredited Member of UKIC. She has published on mineral-preserved organic material for excavation reports on Anglo-Saxon cemeteries.

Gilding as just another finish

Andy Mitchell

Sculptor and Conservator

Whitehall, Alderley, Wotton-under-Edge, Gloucestershire, GL12 7QT

tel/fax: 01453 844253 e-mail: andymitchell@tinyworld.co.uk

Abstract

The paper describes the approach to gilding from the point of view of a sculptor-conservator who deals with the conservation and replication of architectural metalwork and sculpture. The speaker considers himself not to be a gilder but a craftsman who treats gilding as just another finish – indeed as metalwork. Two recent projects are presented to illustrate contrasting approaches to the treatment of gilding: the restoration of John Henry Foley's statue of Prince Albert on the Albert Memorial and the reproduction of the Tara figure from the oriental collection at the British Museum. Both projects demanded different skills and attitudes, from distressing gold leaf with a needle to laying on gold by the square yard.

Key words

Albert Memorial, Tara, metalwork, gilding, reproduction

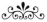

Introduction

Gilding for me is metalwork, no different in spirit to work in the foundry or on the bench. I hold the noble metals in the same respect as other metals or the alloys. I am as fascinated with the gilding on a piece of plaster as with the chromium-plate finish on a car's plastic front bumper. All unoxidized metals have a specious finality about them; they are a finish in themselves, but that is not their natural state. Most metals do their chemical duty and quickly cover themselves up as they react with the world about them, and in doing so create a profusion of rich patinas. The stubbornness of the noble metals not to behave as other metals – not to react – sets them apart, and because of this I have a love-hate relationship with gilding, especially when I find myself gilding over other metals. My experience of gilding tends to be as a finish that is only one part of a project. Indeed, in some cases, I bring in professional decorators to do the final hands-on gilding work, depending on the scale of the job in hand. But I often do the work myself. To illustrate my approach to gilding I have chosen two recent, contrasting, projects.

The British Museum 'Tara'

In 1999 the Oriental Department of the British Museum decided to have a replica made of one of their major statues – the Buddhist goddess 'Tara'. This magnificent eighth-century Sri Lankan gilded bronze is considered to be one of the most important oriental sculptures in existence. She stands in a classic Buddhist pose, with her right hand in the position of 'Varada Mudni', the Buddhist gesture of charity and gift-giving, and her left hand in the position of 'Kataka Mudni', where a tribute or small symbol could be added. In her hair there is a recess where a small sculpture of the Buddha would have been seated. Her eyes would have been made with coloured stones. The entire figure, standing 1.45 metres high, has been chemically gilded all over, apart from her hair.

The figure was found in the Sri Lankan jungle in the Victorian era, half-buried in the detritus of the jungle floor – the ground-level line can still be seen on the back of the figure. The bronze has naturally corroded, but the figure is almost complete, and a surprisingly large amount of the gilding is intact.

There are areas where the gilding has vanished and a deep brown-black patina has taken over, but the surface remains. It is marked, however, by thousands of corrosion pits of all sizes, some only as big as pinheads but others 20 mm wide or more, where pits have joined together to form large shallow craters. The figure has been expertly cleaned by the British Museum conservation department, and was, I expect, much darker before cleaning. It is covered with some form of clear, protective coating.

The museum told me that they would not be taking a mould of the figure – indeed, no one would touch it. They already had a bronze replica of the figure from a cast taken in the 1920s, and I would be copying this. An accurate rubber mould would be made from the 1920s copy (a raw bronze object without gilding or even a patina), wax impressions would be taken, and these would then be hand worked, referring to photographs of the original in an attempt to get as close a match as possible. The waxes would then be cast into bronze and the bronze cast assembled and handed over to me. My first act on seeing the rough cast was to get it standing up so that I could relate to it – and then go and take a long, hard look at the original in the British Museum.

The museum realized that an exact copy of the Tara was impossible. They could obviously expect a technically competent copy, but a lot would be left to my own judgement and aesthetic feeling.

One of the most important factors was the surface finish of the sculpture. The surface was smooth and effortlessly gilded from one form to another – from hollow to hill without any disruption. The new cast, however, was bumpy: the surface had a lot of what I call 'chatter marks', small areas where tools had bounced off the surface, or the contraction in the casting had been uneven. As gilding is all about surface, the underlying metal surface had to be glass smooth. This meant putting the figure on a fettling frame and taking a metal file to every square millimetre of the surface, and then polishing with finer and finer emery cloth until the required surface was achieved. This took literally hundreds of hours (Fig 1).

Once I had a uniform surface and the sculpture felt like a whole, I was faced with the task of matching the colour of the chemically gilded surface. I would use oil gilding with leaf, trying to imitate a gilt-bronze. This method would be straightforward and yet flexible enough for me to alter the sculpture's appearance and reveal the patinated surface below the gold layer. The surface colour of the original would change with different lighting – the lighting levels in the British Museum are quite low. By putting samples of gold leaf against the surface of the original, it was possible to make an approximate colour match, the closest being a leaf called Citron K. I had decided to attempt to match the ageing process of the bronze. As it had been left in the detritus of a tropical forest floor for hundreds of years, the main corrosion chemical would not have been from mineral acids from the soil, but from the by-products of rotting vegetation, the active ingredients resulting in some form of oxidizing sulphur. Logically, therefore, I would patinate with liver of sulphur to achieve a patina close in colour to that of the figure, and then gild on top.

The patination chemical was dissolved in water and applied with a brush on to metal heated with a large blowtorch. It was a case of trial and error to get the required finish, changing the concentration of the chemical and degree of heat. Once I was satisfied with the finish, the bronze was washed with copious amounts of cold tap water and left to dry for a few days. Washing with

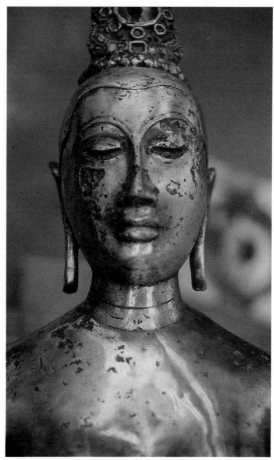

Figure 1 Prepared head ready for patination. © Andy Mitchell

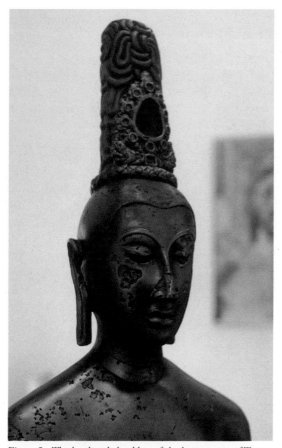

Figure 2 The head and shoulders of the bronze copy of Tara after patination and ready for gilding. © Andy Mitchell

water was supposed to remove any unreacted chemicals from the surface of the bronze, but I knew from past experience that bronzes patinated in this way tend to carry on darkening. This had been taken into account when deciding at what stage to stop colouring the bronze, but it still left me with the problem that a certain amount of active chemical would be on the surface of the metal (Fig 2). In order to achieve a close colour match I had chosen a leaf with 4.5 per cent silver content. Silver oxidizes with sulphur and turns black – would the Citron gold leaf darken too much? I had no time for tests – how long would I need to leave the samples before I could be sure of what would happen? Discretion being the better part of valour, I decided to use $23\frac{1}{2}$ carat gold with only a 1 per cent silver and 1 per cent copper content and accept that the colour match of the surface might suffer. A coloured size might have helped in lightening the colour, but as I would have to relieve the surface after gilding, I risked revealing the coloured size underneath the gold. So a clear 24 hr. gold size was used with the $23\frac{1}{2}$ carat gold leaf (Fig 3). I would attempt not to size the thousands of small corrosion pits and the larger craters on the surface of the bronze. It was impossible to paint around the myriad of tiny marks, but by using an almost dry brush, size could be dragged over the surface and would hopefully not sink into the pits. A sheet of bronze had been patinated at the same time as the sculpture and was then sized and gilded simultaneously – this would be used as a test surface.

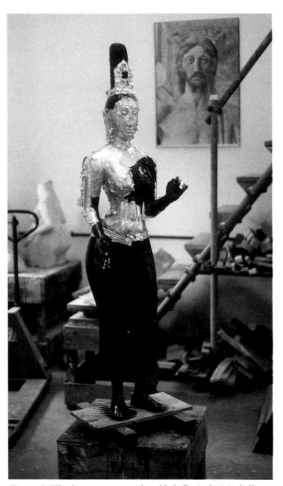

Figure 3 The bronze copy partly gilded. © *Andy Mitchell*

As expected, the gold leaf covered most of the smaller pits, encroached over the edge of most of the medium-sized craters, and, to some extent, even penetrated the larger areas of corrosion. This meant the gold-leafed surface would have to be cut back to give a crisp edge around the corrosion areas, without damaging the patina underneath. Using the test sheet of gilded bronze, different tools and chemicals were tried out before deciding on what to use. To remove the gilding on larger areas, cotton-wool buds lightly dipped in acetone were tried. Gently rubbed into the surface these removed the gilding quickly, but tended to give a soft edge. Softwood splints with pointed ends, dipped in acetone, were used to get into small corrosion pits and this tended to give a sharper edge. A felt-tip pen was adapted, the innards removed and replaced with white blotting paper soaked in acetone to make a type of invisible ink pen – this gave similar results to the wood splints. In the end, after numerous trials, wood splints and thinned-out cotton-wool buds sparingly dipped in acetone and gently rubbed against the surface seemed to be the most effective way of removing unnecessary gilding.

After a week of picking out pits and touching in gilding, working only from photographs, a trip to see the original was needed. Taking a few photographs of my copy, I strolled back into the semi-lit Oriental Galleries at the British Museum to make a comparison. I knew from the start of the project that a perfect copy would be impossible, but I was not prepared to see just how far out I was. I had removed far too much gilding and the general feel of the sculpture was different. My copy had no unity of surface, no shine and, above all, it failed to achieve that immediate 'sexy' response that the original provokes. Parts had worked well, the patina finish was close to the underlying colour of the statue, and where I had thinned the gilding on the head-dress it was well-matched, even though now I noticed a red-brown tinge to it for the first time. The hands and feet had been done well, but my gut reaction as a sculptor was that my copy was a failure, and, after a despondent day and a sleepless night, I had no choice but to strip the sculpture back to bare metal and start again. Learning from my first attempt, I took a longer time to make decisions and trusted my instincts more, referring to the photographs less. After many more trips to the British Museum, clutching the latest photographs, the copy slowly began to evolve and finally the time had come to leave it alone. Technically, the new Tara was a good likeness to the original – more importantly, it had a similar presence. There were still areas where things could have been improved, but most of these were matters of form, not surface, and would have to remain uncorrected. By design, the two sculptures have never been put next to each other. When in London, I often go to the British Museum to have a look at the original Tara. On each visit I see something new, but then one would expect to be continuously surprised by a figure of this subtlety and complexity. By copying the figure I was reminded of how to really look at, and appreciate, a great sculpture (Fig 4).

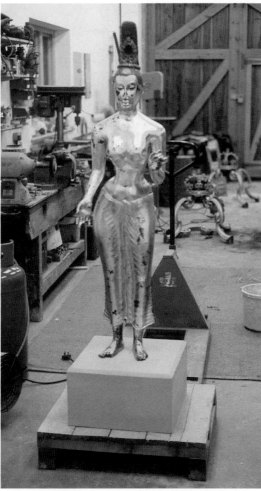

Figure 4 The finished copy mounted on a stone base.
© Andy Mitchell

The Albert Memorial

From a magnificent eastern figure to a magnificent western figure. The figure of Prince Albert on the Albert Memorial was sculpted by the extremely talented Irish sculptor John Henry Foley and cast in bronze by the aptly named Prince Foundry in Southwark, London. The working model was finished in 1870, but in 1874 Foley died unexpectedly and his gifted assistant, the sculptor Thomas Brock, took over and finished the project. Technically, the sculpture is a wonderful example of Victorian craftsmanship and, given its colossal size, one of the most complex attempted at that time.

Late in 1875 a canvas tent was put around the sculpture so that it could be gilded with three layers of gold leaf. The gilding of the sculpture was always controversial and during World War One it was removed with lime in a vain attempt to reclaim the gold. Albert was left, patinated brown, until the recent restoration of the entire memorial began in 1995.

When facing a job as large as this, it is easy to become overwhelmed. Careful planning is therefore essential. It quickly became apparent that the actual gilding of the sculpture would be the simplest part of the whole job. The work divided itself into five main stages – site preparation, cleaning, surface preparation, gilding and protection. When we started we were aware that the restoration of the surrounding monument had almost been finished and any spillage, especially when cleaning, would have to be contained. This meant that the first thing we had to do was to enclose the entire

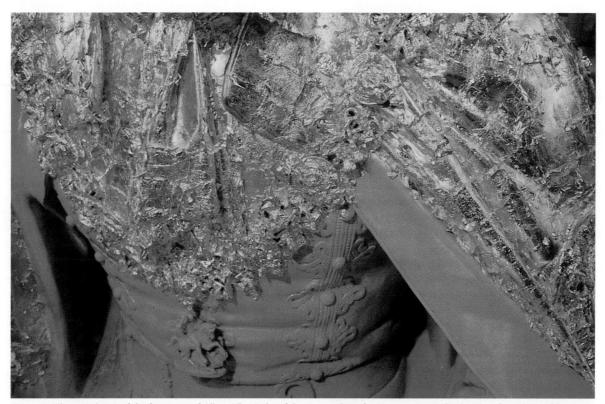

Figure 5 The central part of the front view of Albert. The Order of the Garter chain forms a convenient dividing line for a day's gilding to finish on. © Andy Mitchell

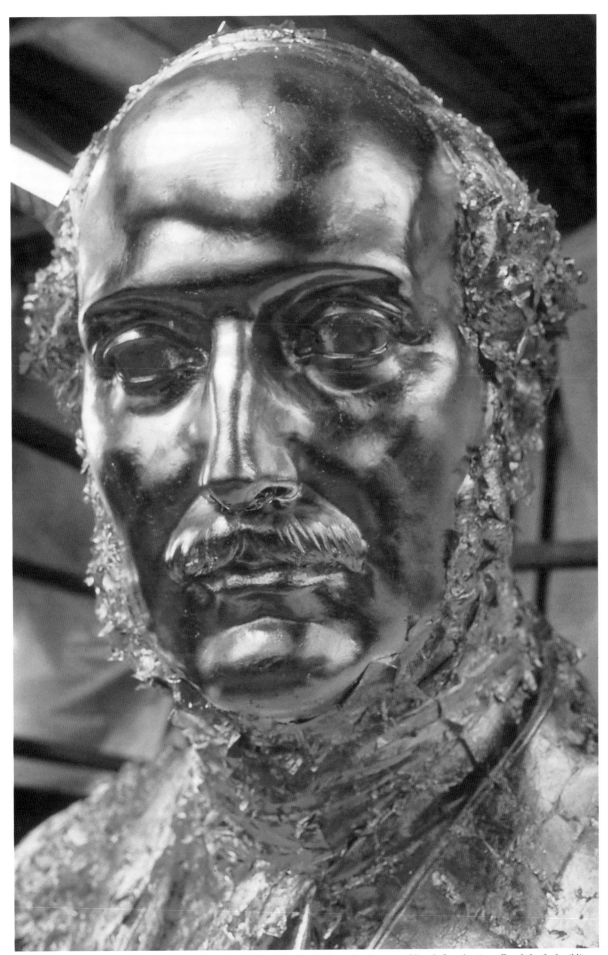

Figure 6 The face of Albert has been finished previously. The joint line is shown by the new gilding before skewing off and the fresh gilding will continue downwards until it meets the Order of the Garter chain. © Andy Mitchell

figure and its scaffolding in a wooden and polythene sheet cube, which would not only protect the sculpture from the wind, but would also protect the monument from dust and air-borne waste material. Water would be used in the cleaning, and we would have to make catches at the base of the sculpture for the resulting slurry. There would also be dustlocks – rather like airlocks in submarines – to allow workers to enter without releasing any dust out onto the memorial. The cleaning machine had its own separate area. We used a JOS machine to clean the surface of the bronze, a low-pressure wet abrasive tool that would clean only as far as the red copper-oxide level – no clean metal would be exposed. (The system used a very small amount of water and compressed air at approximately 2 Bar, with calcite abrasive powder at mesh size MOF, hardness MOHs 3.)

We would start at the top, work down and clear up at the end of each day and empty the slurry catches. It was a slow process. Once the JOS cleaning was finished the entire sculpture was warmed with large propane torches to make sure it was dry, especially in the areas where seams were visible, and brushed down with soft bronze brushes. After a few repairs, mainly filling porosity holes and replacing a few water traps, the sculpture was ready for painting. The reasons for painting the bronze were to improve the surface finish and protect it from bird damage. Birds will easily scratch through gilding, and the exposed bronze produces green-coloured salts that run down the finish, leaving unsightly green stains. The paint was sprayed on using two coats of etch primer, two coats of self-levelling undercoat and finally two top coats of white spirit-based enamel. The top coats were a deep yellow colour (Fig 5). (All the metal sculptures on the memorial that were gilded also had this colour underneath the gilding.) Any bird scratches on the gilding will reveal the yellow paint, but (given the scale and position of the sculptures) it is hoped they will not show. We managed to recover some bits of the original gold leaf from Albert's armpit, so colour matching the gold was not a problem.

Two causes for concern had arisen – air movement and dust. We had vacuum cleaned all the surfaces in the cube before painting, but there was still a lot of dust in the air. Some of this dust attached itself to the polythene sheet, but a lot of fine dust remained in the air, causing problems with the final layer of the top coat, and major problems when sizing. On flat horizontal areas about the base, the top coat of paint had to be gently rubbed down with fine wet and dry paper before sizing. When sizing began we tried to ban visitors (in vain), and maintain a still-air policy. Even so, certain areas picked up dust and had to be flattened and re-sized. Because of the scale of the object, and because we were working from three different scaffolding levels, there were times when we were forced to stand on the sculpture to reach certain places. In an attempt to avoid standing on gilded surfaces, and bearing in mind that we were double gilding, some areas had to be double gilded before other areas could even be begun. To avoid finishing gilding on a flat surface, and thereby causing a visible differentiation in the texture, each day's gilding was kept within an area that had a natural boundary marked by a change in the sculpture's surface (Fig 6). Finally, the base was gilded, the entire sculpture was loosely covered with washed muslin cloth to protect it from dust and curious fingers, and the gilding was allowed to harden.

Working physically so close to the sculpture made an overall view of the sculpture impossible at the time, and it was only at the unveiling ceremony that we could see how the gilded Albert looked and how it fitted into the surrounding monument.

Conclusion

The two sculptures discussed above are clearly very different in many ways – gilding, however, was integral to both. Unlike other cases involving new or newly restored sculptures, where, as the work nears completion, a last-minute decision is made to gild, and the results are usually (though not always) disastrous, both were conceived as golden from the first. I have often called gilding the ultimate cover-up job – the quickest way to flatter and flatten a piece of sculpture. But it is important not to be dogmatic about this, and to recognize that a golden finish can also be integral to the identity of a sculpture, not merely an opulent, optional extra.

Materials and equipment
Gold leaf:
James Laird (Goldbeaters) Ltd, 18 Craig Road, Cathcart, Glasgow, G44 3DW. tel: 0141 637 8288
Chemicals:
(Hazard data sheets should be obtained from the suppliers and COSHH assessments carried out before use).
Merck Ltd, Merck House, Poole, Dorset BH15 1TD. tel: 01202 669700
JOS machine:
Stonehealth Ltd, Dursley, Gloucestershire, GL11 4JE. tel: 01453 540600 fax: 01453 640609
www.stonehealth.com

Health and safety
When using acetone the appropriate gloves and goggles should be worn, with personal respiratory equipment or fume extraction.

Biography
Andy Mitchell studied sculpture in London during the 1970s. Since then he has worked as a sculptor and bronze founder, working from a studio and foundry at his home in Gloucestershire. He is a recognized expert on the conservation and restoration of metal sculpture and architectural metalwork. He was responsible for the restoration of all the metal sculptures on the Albert Memorial, winning a Royal Institution of Chartered Surveyors Building Conservation Award for his work. Major clients include English Heritage, the National Trust and the British Museum. He is an elected Brother of the Art Worker's Guild and an Accredited Member of UKIC.

The treatment of gilt-bronze in the Wallace Collection: The cleaning and conservation of the F68 Balustrade

Paul Tear

Head of Conservation

The Wallace Collection, Hertford House, Manchester Square, London W1U 3BN

tel: 020 7563 9510 fax: 020 7224 2155 e-mail: ptear@wallace-collection.com

Abstract

In June 1994 the Wallace Collection decided to refurbish the Main Entrance both to improve visitor access and to bring it closer to its appearance in 1897 (the date of Lady Wallace's bequest to the nation). As an integral part of these works, it was decided that the Grand Staircase Balustrade F68 should be dismantled, cleaned and conserved. The Balustrade is regarded as one of the finest surviving early eighteenth-century masterpieces of French interior architectural metalwork outside France. The project involved conserving over 1,000 items of gilt-bronze. This task was approached using conservation trials to assess the various options for cleaning methods and materials. Metallurgical analysis was also carried out to ascertain whether the mounts had originally been mercury gilded, and to see if there was a difference in the metals between the eighteenth- and nineteenth-century castings.

Key words

Gilt-bronze, shellac, Paraloid® B72, XRF analysis, electro-plating, gilding

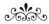

History

On 10 November 1717 the Hôtel de Nevers on the rue de Richelieu in Paris was surveyed in order to adapt it as the future Bibliothèque du Roi. The survey stated that the staircase had no balustrade, and calculated that a total of $11\frac{1}{2}$ *toises* (1 *toise* = 1.94 m, total 22.31m) of balustrade was required. However, on 10 May 1719 it was sold to the financier John Law for 400,000 livres, to house the Banque Royale instead. The Balustrade was probably installed on his orders between May 1719 and the end of 1720, when Law's financial system crashed.

In May 1724 Louis XV issued a letters patent acquiring the Hôtel de Nevers for the Bibliothèque du Roi once again, and on 20 August 1725 the Hôtel was surveyed by Charles François de l'Espée, who in his report made special reference to the Balustrade ('Le Grand Escalier … une belle rampe de fer garnie et ornée de bronze'). The plan of the Balustrade was recorded by Blondel twenty-nine years later – *Architecture Française* (1754) shows it as the single-sided balustrade of a three-

flight staircase. The Balustrade was described on the rue de Richelieu side of the Bibliothèque in 1782 by Le Prince, and again in 1787 by Thiéry.

The Balustrade was eventually removed by the architect Labrouste between 1868 and 1874; it was bought by Sir Richard Wallace in about 1871 and was installed as a double-sided balustrade in Hertford House three years later by the firm of Geslin, who charged 54,938 French francs for altering and lengthening it to fit its present location (Hughes 1996) (Fig 1).

Previous and recent treatment

In June 1994 the Wallace Collection decided to refurbish the Main Entrance to improve visitor access and to bring it closer to its appearance in 1897 (the date of Lady Wallace's bequest to the nation).

As an integral part of these works, it was decided that the Grand Staircase Balustrade (regarded as one of the finest surviving early eighteenth-century masterpieces of French interior architectural metalwork outside

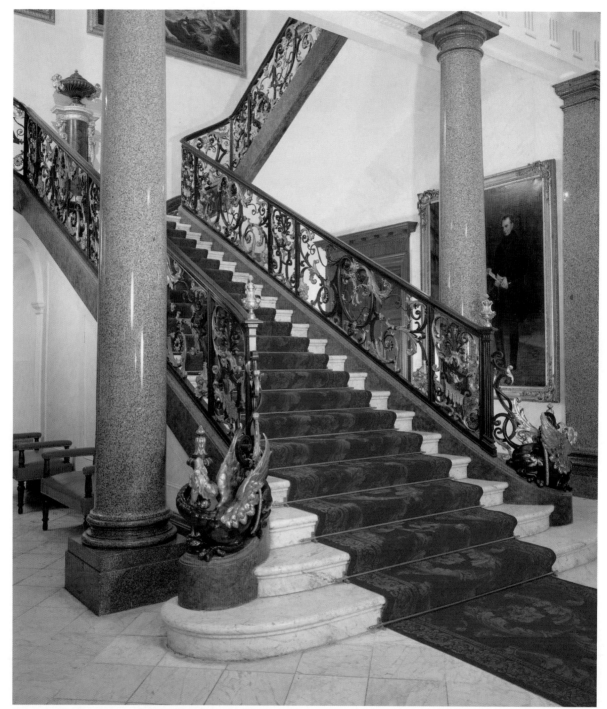

Figure 1 The front entrance of The Wallace Collection showing Balustrade F68. The griffins in the foreground are nineteenth-century.
© The Wallace Collection. By kind permission of the Trustees of the Wallace Collection

France) should be dismantled, cleaned and conserved. It was last cleaned in 1967, when the mounts were soaked for long periods in a caustic solution of sodium sesquecarbonate to remove the discoloured lacquer. After this, if they were not considered sufficiently bright, they were dipped in acid, rinsed and hot lacquered [1] (Fig 2).

In contrast, the emphasis now was much more upon scientific analysis and conservation, and from the outset it was the intention of all involved never to resort again to such potentially harmful cleaning and 'brightening' techniques. In the event, the removal of the discoloured 27-year-old shellac-based varnish from the mounts has in itself made an enormous difference to the visual appearance of the Balustrade. The application of a modern acrylic lacquer (Paraloid® B72), with its inherent properties of long-term strength and stability, should ensure that this effect will not wear off so quickly.

Conservation panel trials

At an early stage in the planning process for the cleaning and conservation of the Grand Staircase Balustrade, advice was sought from the Wallace Collection Conservation Panel, comprising experts drawn from the United Kingdom, Europe and America. A range of alternative treatments and possible surface finishes was

Figure 2 Back of mount showing bright finish, possibly acid-dipped in a previous treatment.© The Wallace Collection. By kind permission of the Trustees of the Wallace Collection

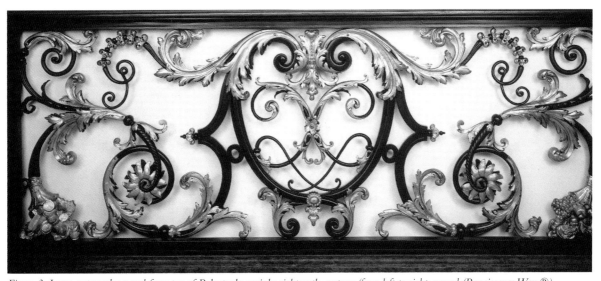

Figure 3 Large rectangular panel from top of Balustrade, mainly eighteenth-century (from left to right: waxed (Renaissance Wax ®), nitro-cellulose lacquer, untreated).© The Wallace Collection. By kind permission of the Trustees of the Wallace Collection

presented by the Wallace Collection Conservation Department for discussion and assessment, and a number of trials were carried out.

One trial involved deciding whether to wax or lacquer the mounts, or even to leave them completely untreated, once the old discoloured varnish had been removed. These three different surface treatments were applied to the three main parts of the centre section of the Balustrade on the first floor landing (Fig 3), and members of the panel were then invited to comment.

After long and interesting discussions with the members of the panel (who put forward various treatment proposals, from gently rinsing the mounts in mineral spirits [white spirit], to regilding them), it was agreed that

lacquering was the best option. Further trials to choose the most appropriate lacquer took place, the most favourable results being achieved with Paraloid® B72.

An important consideration in the final choice was this lacquer's known longevity, since it was intended that the present treatment should last for at least the next twenty years: other lacquers (Ercalene® nitro-cellulose lacquer, for example), were known to become difficult to remove after such a time span. It was decided to try to apply Paraloid® B72 by spraying, in order to achieve a good, even covering on the mounts.

Up until this time we had normally, as a workshop, applied our lacquers by brush. We therefore carried out trials on copper coupons to ascertain the best solvent(s)

and the percentage of Paraloid® B72 to use (see Appendix 1). We also looked at how quickly it dried and its scratch resistance. (This was carried out in a very scientific manner. We ran our thumbnails over the surface of the coupon: if it scratched, it failed; if the film remained intact, it passed.)

A 2 per cent w/v solution of Paraloid® B72 in acetone and diacetone alcohol (85 per cent/15 per cent v/v) was chosen, having performed best during the tests. One coat on the back and four coats on the front gave good cover and an acceptable, non-glossy finish.

Conservation treatment: the ironwork frame

Only after work had actually begun on the first-floor landing centrepiece section of the Balustrade was it noticed that, under the powerful arc lights being used by the contractors working in the stairwell, the colour of the painted ironwork (hitherto always presumed by everyone to be black) had in fact rather a greenish hue. Preliminary cleaning of some small areas with white spirit seemed to bear this out. Before any further cleaning was undertaken, a number of samples were taken of the paint layers present on the ironwork, and submitted for microscopic examination by Dr Nicholas Eastaugh, Dr Ian Bristow and Patrick Baty. From the cross-sections analyzed it was revealed that the original (1874) colour of the ironwork was probably a dark, so-called 'bronze', green. Four layers of green were discovered, over one coat of red lead primer, all applied in London after 1874. Only the final (almost certainly twentieth-century) layer was black. Unfortunately, no trace was found of any earlier (pre-1874) colour schemes.

Following this discovery, the green colour was matched and, disturbing the original surface as little as possible, the painted ironwork was de-waxed using white spirit and then repainted in modern Dulux®-based eggshell, to return it to its 1874 colour. The decision to use a modern paint was taken after discussion with historical paint experts. It was thought that it would be helpful in any future analysis of the paint layer if the top layer was clearly modern.

The mounts

Each section of the Balustrade was dismantled, individual mounts being mapped and numbered on a standard form devised for the purpose. Each mount was photographed in black and white, both front and back, prior to conservation. This has given us a permanent record of any marks or numbers, and the pre-treatment condition. The mounts were soaked in Industrial Methylated Spirit (IMS) overnight, then lightly brushed with a soft bristle brush and fresh IMS; small fragments of old lacquer were picked out with a swab stick. Shortly after the cleaning programme was begun it was noticed that the mounts needed to be left to soak in IMS for longer periods in order to remove the old lacquer. We therefore looked for a different solvent. After consulting a Teas-chart we tried diacetone alcohol – this proved to

be very successful, so we continued the soaking process with it. Then, after a final rinse in acetone, the mounts were hung up to dry, and immediately spray-lacquered with Paraloid® B72 to prevent oxidation of the surface.

The brass screws were retained in their original positions, though many were modern and there did not appear to be any original finish remaining on them. The Ercalene® lacquer on each one was removed with 60 per cent acetone/40 per cent toluene (v/v) and further cleaning was kept to a minimum. A layer of Paraloid® B72 was brushed onto the screwheads after final reassembly of each Balustrade section.

Structural analysis

This conservation project was an ideal opportunity to study and record the structure of the Balustrade. No one knew precisely how much was French early eighteenth-century, and how much was nineteenth-century, but in its original form it was shorter by nearly four metres, so it must have been lengthened to fit its present location. Analysis and research was hampered by the sheer size of the task: over 1,000 gilt-brass mounts and nearly 26.5 metres of ironwork had to be assessed.

As each panel was taken down and dismantled, the back of every mount was examined, photographed, and any marks or numbers struck into the metal noted. One construction phase was indicated by letters and numbers that were of an eighteenth-century style (often matching those struck on the ironwork supporting the mounts (Fig 4)) dating back to the first assembly of the Balustrade in the Banque Royale. Another was indicated by a complete absence of marks, mainly on mounts taken from the short panels (nineteenth-century in origin). Casting marks, together with plugged or altered attachment holes, provided further evidence of major structural alterations, presumably dating from the 1874 reconstruction.

Metallurgical analysis

A systematic programme of non-destructive metallurgical analysis was carried out by Dr Brian Gilmour of the Royal Armouries Conservation Department, using their energy-dispersive X-ray fluorescence (XRF) equipment (see Appendix 2).

In a significant reassessment of the Balustrade, all of the sections were found to contain nineteenth-century elements, some of the panels being entirely nineteenth-century. This suggests a considerable degree of reconstruction, even if we are still justified in regarding the long panels as predominantly original with the shorter ones added c. 1874 to make up the length.

XRF analysis has revealed that the mounts themselves are brass, not bronze as was previously thought. Metallurgically, the original early-eighteenth-century mounts (approximately 74–81 per cent copper to 16–24 per cent zinc, plus impurities) differ from the nineteenth-century ones (67–73 per cent copper to 26–32 per cent zinc, with far fewer impurities). Three or four of the mounts examined, however, proved to be slightly different again; these were perhaps recast from

Figure 4 Iron framework showing punched number, which originally corresponded to gilt-bronze.© The Wallace Collection. By kind permission of the Trustees of the Wallace Collection

others that were presumably either faulty or otherwise unusable in the reworked design, and that had therefore been melted down for re-use.

XRF analysis of the gilding layer was undertaken to identify any traces of mercury, which would have confirmed the presence of original fire-gilding, but none was found; all the mounts appear to have been electro-gilded during the 1874 reconstruction. As one would expect, the early eighteenth-century finish of the mounts was probably *mise en couleur* (brass, polished or acid-dipped to brighten it, then lacquered to preserve the finish), a well-known technique of the day used to simulate gilt-bronze. The relatively poor quality of the chasing tends to support this.

In order to supplement the XRF surfaces analysis, a small (2 mm by 1 mm) sample was taken from an eighteenth-century mount for electron microprobe testing by Dr David Scott of the J. Paul Getty Museum. The results from this analysis confirmed that the mounts had been electro-gilded. There were also small traces of mercury (0.53 per cent) present, but this level is too low for the gold to have been applied by the mercury amalgam process and is probably due to mercury salts being added to the plating solution to aid the plating process (Fig 5).

Conclusion

Through analysis and the processes of conservation we have obtained firm evidence for many hitherto unproven theories, and ascertained the following:

- The mounts are brass rather than bronze.
- There are two distinct groups of brass composition, which helps us to differentiate between the eighteenth- and nineteenth-century brass mounts.
- The large sections of the Balustrade date from the early-eighteenth century, but nonetheless contain a small percentage of nineteenth-century mounts.
- The half-landing corner sections are eighteenth-century in origin.
- The small sections date from the 1874 reconstruction.
- The pair of griffin figures at the base of the staircase also date from 1874.
- Some of the eighteenth-century mounts were used in 1871–4 as models for casting mounts on the small sections.
- There is no evidence that any of the mounts were ever mercury-gilded.
- The gilding of the mounts is nineteenth-century (electro-plated).
- The ironwork was painted green in 1874 and was subsequently blackened (a cross-section shows uniform paint layers with no dirt present between them – Fig 6).

The Grand Staircase Balustrade at Hertford House is still functional and in use every day; the choice of conservation treatments had to take account of this. Our decision to use lacquer on the mounts and paint on the ironwork, for example, was influenced by the fact that every visitor

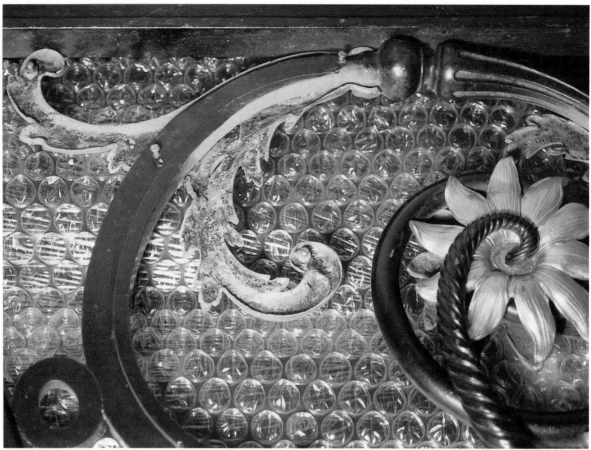

Figure 5 Back of mount that still retains blanking-off wax used during the electro-gilding process.© The Wallace Collection. By kind permission of the Trustees of the Wallace Collection

Figure 6 Cross-section showing paint layers: orange-red primer, green paint, black paint/black wax.© The Wallace Collection. By kind permission of the Trustees of the Wallace Collection.

to the collection would use the staircase. Unless fully protected, it could easily be abraded by clothing and bags lightly coming into contact with surfaces. The entire procedure of analysis and conservation took just over one year, but it is envisaged that no further large-scale treatment will be required for the next twenty-five years or more, other than routine monitoring of condition.

Notes
1. Wallace Collection file, F68.

References

Blondel F., 1754 *Architecture Française*, Paris

Hughes P., 1996 The Wallace Collection Catalogue of Furniture, Vol III, No 230 (F68)

Acknowledgements

I am grateful to Dr Brian Gilmore for carrying out this analysis and for giving his permission to publish the results. I would like to express my thanks to Dr Nicholas Eastnaugh and Dr David Scott for their help and encouragement during this project.

I would like to thank all the members of The Wallace Collection conservation department for their support throughout this long and sometimes daunting project. In particular I would like to thank Peter Hughes, Head Curator, and David Edge, Senior Metalwork Conservator, for their invaluable help and support. To all the interns and volunteers who helped with this project, all I can say is we could not have done it without you.

Materials
Paraloid® B72:
Conservation Resources (UK) Ltd, Units 1, 2 and 4, Pony Road, Horspath Industrial Estate, Cowley, Oxford OX4 2RP. tel: 01865 747755
Paint:
Paper and Paints Ltd, 4 Park Walk, London SW10. tel: 0207 352 8626
Chemicals:
(Hazard data sheets should be obtained from the suppliers and COSHH assessments carried out before use).
R. and L. Slaughter Ltd, Units 11 and 12, Upminster Trading Estate, Warley Street, Upminster, Essex RM14 3PJ. tel: 01708 227140 fax: 01708 22828

Biography

Paul Tear trained as a cabinet-maker and furniture restorer during an apprenticeship with a leading firm of restorers. He also attended the London College of Furniture to obtain a City and Guilds in furniture craft. He joined the Museum of London in 1978 and assisted the move from Kensington Palace to the present site. In 1979 he took up the post of Conservation Officer at the Wallace Collection and is presently Head of Conservation. He specializes in the conservation of French furniture, and he has recently worked on the removal of oil staining from marquetry. He conserved the Grand Staircase at Hertford House in 1995.

Appendix 1

RESULTS OF LACQUER TRIALS					
Solvent	Solute	Coats	Tack time	Scratch test	Matt finish
Xylene	6% w/v Paraloid B72	3	Acceptable	48 hrs+	1
25 ml Diacetone Alcohol/ 175 ml Acetone	3% w/v Paraloid B72	1	Acceptable	24 hrs	1
Mylands Duralac		1	Acceptable	24 hrs	2
25 ml Diacetone Alcohol/ 75 ml Acetone	1.5% w/v Paraloid B72	6	Acceptable	24 hrs	3
25 ml Diacetone Alcohol/ 75 ml Acetone	3% w/v Paraloid B72	3	Acceptable	24 hrs	4
75 ml Solvent Spirit	25% v/v Ercalene	1	Acceptable	24 hrs	5
25 ml Diacetone Alcohol/ 275 ml Acetone	1.5% w/v Paraloid B72	6	Acceptable	24 hrs	6
Xylene	3% w/v Paraloid B72	3	Acceptable	24 hrs	7
25 ml Diacetone Alcohol/ 175 ml Acetone	3% w/v Paraloid B72	3	Acceptable	Fail	8
1-Methoxypropane-2-ol	3% w/v Paraloid B72	3	Acceptable	24 hrs	9
1-Methoxypropane-2-ol	6% w/v Paraloid B72	3	Acceptable	48 hrs	10
20 ml Diacetone Alcohol/ 80 ml Acetone	2% w/v Paraloid B72	4	Acceptable	18 hrs+	11
25 ml Diacetone Alcohol/ 275 ml Acetone	1.5% w/v Paraloid B72	1	Acceptable		11
25 ml Diacetone Alcohol/ 75 ml Acetone	6% w/v Paraloid B72	1	Too Slow	24 hrs	12
Acetone	6% w/v Paraloid B72		Too Quick		

Diacetone Alcohol	6% w/v Paraloid B72		Too Slow		
25 ml Diacetone Alcohol/ 175 ml Acetone	3% w/v Paraloid B72		Acceptable	36 hrs	12
25 ml Diacetone Alcohol/ 175 ml Acetone	3% w/v Paraloid B72	4	Acceptable	18 hrs+	12
25 ml Diacetone Alcohol/ 275 ml Acetone	1.5% w/v Paraloid B72	6	Acceptable	18 hrs+	12

Coats = Number of coats applied.

Tack Time = After 10 minutes the coating should have hardened enough to enable another coat to be applied.

Scratch Test = After 24 hours a simple test (scratching with a thumbnail) was used to determine if the coating had adhered to the coupon.

Matt Finish = The coupons were arranged in order, with 1 being the most matt and 12 the most glossy.

Appendix 2

PERCENTAGE OF ELEMENTS BY WEIGHT									
Sample	Fe	Ni	Cu	Zn	Pb	Ag	Sn	Sb	Comment
1	0.54	0.05	74.3	22.9	1.69	0.08	0.44	0.09	E
2	0.22	nd	71.6	27.8	0.21	nd	0.09	0.05	?N
3	0.50	0.03	75.0	21.7	1.64	0.10	1.04	0.06	E
4	0.54	0.05	76.6	20.7	1.58	0.06	0.49	0.06	E
5	0.32	nd	70.8	27.8	0.96	0.04	0.07	0.04	N
6	0.48	0.05	71.5	27.1	0.80	0.02	0.10	0.02	?N
7	0.12	0.02	69.3	29.1	1.34	0.02	0.15	0.02	N
8	0.15	nd	69.7	29.1	0.96	0.02	0.03	0.03	N
9	0.24	0.07	69.4	29.3	0.89	0.02	0.08	0.02	N
10	0.20	nd	70.2	28.4	1.10	0.04	0.07	0.04	N
11	0.23	0.02	72.2	26.5	0.96	0.03	0.07	0.01	?N
12	0.12	0.03	69.6	29.1	1.08	0.02	0.10	0.03	N
13	0.24	0.04	72.4	26.3	0.83	0.04	0.11	0.03	?N
14	0.22	0.05	73.8	24.9	0.78	0.02	0.19	0.03	E
15	0.44	0.03	74.0	22.1	2.16	0.05	1.15	0.08	E
16	0.41	0.06	74.7	24.0	0.51	0.02	0.35	0.03	E
17	0.21	0.07	74.7	23.9	1.04	nd	0.09	0.04	?N
18	0.17	0.11	74.9	23.4	1.50	nd	0.06	0.03	?N
19	0.48	nd	78.7	17.8	1.61	0.08	1.20	0.15	E
20	0.45	nd	78.9	17.5	1.89	0.10	1.17	0.11	E
21	0.23	nd	66.7	31.9	0.96	nd	0.16	0.04	N
22	0.43	nd	77.3	19.9	1.46	0.10	0.85	0.07	E
23	0.38	nd	81.4	15.5	1.54	0.07	1.05	0.09	E
24	0.21	nd	68.6	30.0	0.96	nd	0.09	0.02	N
25	0.40	0.06	75.7	21.0	1.72	0.10	0.90	0.07	E
26	0.45	0.08	79.3	18.3	1.18	0.07	0.53	0.08	E
27	0.52	0.19	74.8	22.7	1.33	0.06	0.40	0.08	E
28	0.45	nd	78.9	18.7	1.40	0.07	0.55	0.09	E

Key

E = c. 1720

N = c. 1874

nd = Not Detected

5

Gilding conservation in an architectural context

Duncan Wilson

BA Arch, RIBA Architect

Peter Inskip and Peter Jenkins Architects Ltd, 1 Newbury Street, London, EC1A 7HU
tel: 020 7726 8977 fax: 020 7796 3930 e-mail: ijarch@globalnet.co.uk

Abstract

In the past the use of colour and gilding schemes externally was often an essential component of the overall design and presentation of a building, equal in importance to the detailing and massing of the structure. All too often, in the intervening period, this relatively fragile and maintenance-dependent element has been lost as a result of weathering, economic stringency or fluctuations in fashion. The disappearance of such regularly maintained surface finishes leaves the fabric exposed to the elements and subject to degradation. Attempts to restore external historic decorative schemes, particularly those involving gilding, must take into consideration this degradation as well as the measures required to produce surfaces suitable for the application of replacement finishes. The recent repair of the Albert Memorial, London, is used to illustrate the problems encountered in restoring the structural and aesthetic integrity of a building.

Key words

Albert Memorial, finishes restoration, architectural gilding, bronze, Portland stone, lead

Introduction

The nineteenth century saw considerable experimentation in exterior decoration: the Greek, and, in particular, the Gothic Revivals encouraged the structural use of colour and decorative elements, emulating and 'improving on' the archaeological interpretation of the original. This was coupled with the availability of, and the wish to use, newly developed building materials of real or imagined durability: permanent and rich coloured pigments, Roman cements, hard-fired and glazed ceramics, glass mosaic, wrought iron, etc. As a material with an acknowledged durability, gilding was often a significant element in such schemes.

During the years following the completion of such buildings, the decoration has become disrupted to a greater or lesser extent as a result of weathering, fashion, the durability of the material used, or the durability of the substrate to which they were applied. Proposals to restore or conserve the decoration can be ethically complicated, involving issues in different fields of conservation.

In this paper I take as a case study the recent repair of the Albert Memorial, a building whose appearance is fundamental to its use, and the decisions made regarding the restoration of its complex dec-orative scheme.

Design

George Gilbert Scott claimed several sources of inspiration for his design for the Albert Memorial. The first, deliberately chosen to please the grieving Queen Victoria, was the Eleanor Crosses, carved by William of Ireland to mark the resting places of the bier of Edward I's consort on its slow journey from Lincolnshire to London. Another, of more direct interest to us, were the precious reliquaries and shrines fabricated by medieval fine metalworkers to house the bones of saints – or, to be more precise, the notional structures that were their inspiration (Fig 1). As Scott states in his *Recollections*:

> The object at which I have aimed is, so far as possible, to translate back again into a real building the idea which must have floated in the imagination of those ancient shrine-makers; and to produce in reality such an ideal structure as they adopted – without ever having seen it except in their minds' eye – as the models of their fairy structures.

Figure 1 Medieval reliquary – The Shrine of the Three Kings, Cologne.

The reproduction of the intricacy and preciousness of such a 'fairy' design, when expanded on the gargantuan scale of the Memorial, required careful consideration, further complicated by the need for materials that would survive the aggressive environment of nineteenth-century London. After recommendations, cost assessments and trials, Scott finally specified a wide range of metals and stones, each finished in different ways, either to exploit their natural character, or to serve as a base for subsequent applied surface finishes:

- **Cast iron**
 Plain structure of spire, clad with lead.
 Decorative posts of railings and gates, painted and gilded.
- **Wrought iron**
 Plain structure of spire, clad with lead.
 Decorative, finely-smithed railings and gates, painted and gilded.
- **Lead cladding**
 Assembled cast ornament on the spire, gilded or painted black and set with glass 'jewels'.
- **Copper alloys**
 Sculpture, gilded or patinated and lacquered.
 Scrollwork and foliage, gilded.

- **Portland stone**
 Structure, framing and mouldings of gables, pinnacles, arch spandrels and vault; carved, some parts gilded, some parts painted black, the remainder naturally dressed. Set with cast glass and polished stone 'jewels'.
- **Sandstone**
 Carved structure: main capitals and gargoyles, wholly gilt.
- **Granite (carved)**
 Polished grey, pink and red granites used for string courses on plinths, the main structural columns and decorative attached columns and 'jewels'. Natural variations in tones were carefully selected for specific locations.
- **Granite (tooled)**
 Grey and pink granites used for steps and outer plinths.
- **Marble**
 Hard-wearing white Campanella marble used for frieze and low-level sculptural groups, also cladding plinth below statue of Prince Consort where it was partly gilt.
- **Glass**
 Mosaics applied to gables, spandrels dedication and vault. Gold-laminated glass pieces ('smalti') were used as background to the figures.

Blown glass 'jewels' and flat panels set into the lead cladding, cast glass 'jewels' set into the Portland stone.
- **Paving**
 Selected paving stones: one limestone, two sandstones and a slate in four contrasting colours, ground, cut and arranged in patterns around the base of the Memorial.

At the time of the restoration one hundred and thirty years had elapsed since the completion of the Memorial. During that time it had suffered damage from weathering and acts of both official and unofficial vandalism. Inevitably, the different materials and degrees of exposure resulted in different amounts of weathering and disruption.

Significant interventions since 1876

The gold 'smalti' of the mosaics failed soon after completion and were replaced at the turn of the century. The Venetian manufacturers had been unaware of the effect that the damp, frosty winter weather in England would have, attacking the vulnerable edges of the smalti and causing them to fail along the line of gold lamination.

In 1916, when the decoration of the Memorial had probably deteriorated to a condition that required considerable intervention, the Office of Works carried out a 'toning-down' exercise on the building, reducing future maintenance and producing an appearance more in tune with the taste of the time.

During World War Two the Memorial was badly damaged by gunfire, the embarassing result of poor marksmanship on the part of the anti-aircraft battery situated in nearby Hyde Park. Unfortunately, the repairs that followed did not maintain the standard of the original work and further diluted the power of the building.

The latest repairs commenced with surveys and inspections in 1989 and the works were completed in October 1998. The treatment of the three most significant visible materials of the spire – the bronze, the stone and the leadwork – is detailed below.

Bronze/copper

The cast bronze leafwork that forms an important part of the decoration of the spire, and the electroform copper sculptures that stand on and against it, originally had a gilt finish. There is also the proud boast in a souvenir volume that the statue of the Prince Consort was triple gilt. This gilding was removed in 1916 as part of the general 'toning down' of the Memorial. Since that time the bronze and copper had been subject to active corrosion, and had become a source of copper-rich washes that badly stained the marble and Portland stone below.

All the pieces from the spire required treating and protection from the environment, and the most appropriate method of achieving this was to restore the original gilded finish. They were therefore taken to the workshops of two specialist contractors, cleaned thoroughly of all corrosion, using the JOS wet-abrasive system and calcium carbonate medium, then painted with an AKZO Sikkens

paint system developed for car body protection: a first coat of two-pack wash primer, then a coat of non-sanding two-pack chromate-free primer/surfacer, and an alkyd-based synthetic enamel. The size and gilding followed after the enamel had fully cured.

The paint system, which was also applied to the interiors of statues, was designed to provide maximum corrosion protection, reducing the possibility of disruption and failure of the gilding due to corrosion of the metal below. This was particularly important given the inaccessibility of the gilded items.

The Cross and Orb were replaced in the 1950s after loss of the original during the Second World War (Fig 2). Unfortunately, the plain bronze replacement bore little resemblance to the lead-clad original, with its glass jewels and gilding. In order to restore the original appearance of the Cross, the bronze structure, which was soundly built, was decorated with cast lead elements, copied from similar leadwork on other parts of the building and matching that shown on early illustrations. Here the gilding, applied overall, serves to homogenize the disparate parts (Fig 3).

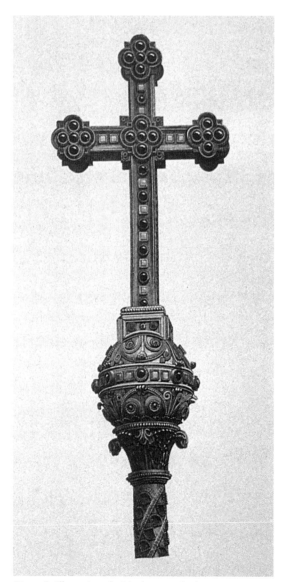

Figure 2 Illustration of original cross and orb.

Figure 3 Bronze orb with decoration being applied during restoration. © Duncan Wilson

Structural stonework

The Darley Dale and Portland stone of the pinnacles, gables and main arches was finely carved by Farmer and Brindley, and heavily gilded. The gold was further accentuated by painting the undercut shadows black. A large amount of this gilding was removed in 1916, but the blackening of the shadows was retained. By the time of the repair of the Memorial, although much of the remaining gilding had been lost or was in a very frail condition, and the unprotected stone had weathered by up to 12 mm, sufficient remained to consider and agree upon a conservation approach.

Care was taken to retain as much of the original fabric as possible: the stone was first cleaned with sequenced mist sprays or micro air-abrasive, and Paraloid® B72 applied to the crazed and broken gilding to consolidate it.

Regilding was strictly limited because the preparation of a sound, smooth base would involve the obliteration of the remaining Farmer and Brindley carving, either as a result of recarving or of building up with mortar (Fig 4). Instead, the predominant material in each architectural element – normally the ochre bole, but occasionally the gilding – was used to make up and homogenize the element and enhance its legibility. The top half of the north-east pinnacle, replaced after the Second World War and never gilded, was partially gilt to match the original section below. A conscious decision was taken to gild certain elements, usually when they

Figure 4 Trial consolidation of gilding on stone. © Duncan Wilson

Figure 5 View of roof showing gilded bronze ridge, conserved gilding on stone pinnacle in distance and selective gilding of lead column shaft in foreground. © Duncan Wilson

related directly to elements of the structure fabricated from different materials that were themselves gilded: the pinnacle finials echo the lead and bronze ones on the gables, the main arches engage with the strong horizontal band of the gilt mosaic dedicatory frieze. In these cases, however, the stone was only lightly prepared and the gold applied to a relatively rough surface.

Leadwork

At the time of the repairs there was substantial evidence remaining, both of the gilding originally applied to large areas of the lead and of the contrasting blackened shadows (applied here, as on the stonework, to enhance the adjacent gilding). However, much of the finish was fragile and very dirty. This dirt precluded consolidation as the fragility of the gilding made any traditional methods of cleaning unsuitable. However, during trials that used a pulse laser to clean the glass jewels set into the leadwork, it was found that the laser was also very effective at removing dirt from the loose flakes of gold. Once cleaned, the gilding could be consolidated with Paraloid® B72.

Unlike the bronze, the leadwork does not rely on applied finishes for longevity. On the other hand, unlike the stonework, preparation for gilding on it does not mean major intervention for the existing fabric. The basis for restoring the gilding on the leadwork was therefore governed by aesthetic judgement (Fig 5), ensuring that neither the fully gilt bronzework, nor the stonework

bearing limited gilding, should look odd or isolated.

The main architectural lines, defining the edges of columns, pinnacles, arches and gables of the spire leadwork were regilded, visually supporting the gilded bronze foliage. Gable finials were also gilded, but the decoration and patterning within the panels remained as conserved historic gilding.

Conclusion

During the recent repair of the Albert Memorial decisions were taken regarding the balance between conservation of the existing finishes and restoration of the finishes, particularly the gilding, as originally envisaged by George Gilbert Scott. The final result is only one of many possible options, but one that in our opinion protects (by increasing the weathering capacity as far as is practical), improves and highlights the legibility of the building, and does not restrict the options of those carrying out the next major works, tentatively programmed for sixty years' time (Fig 6).

Bibliography

Gilbert Scott G., 1879 *Personal and Professional Recollections*, London, Sampson Low, Marston, Searle and Rivington.

Figure 6 View of the Albert Memorial after repairs. © Duncan Wilson

Acknowledgements

Specialist conservators employed during the recent repairs:
Bronze statuary, including Cross and Orb: Andy Mitchell Sculptures
Bronze leafwork: Dorothea Restorations Ltd
Stonework: Nimbus Conservation Ltd
Leadwork: Eura Conservation Ltd

Materials and equipment
JOS wet-abrasive cleaning system with vortex nozzle and calcium carbonate medium:
Pulse laser with flexible operating head:
Stonehealth Ltd, 73 London Road, Marlborough, Wiltshire SN8 2AN. tel: 01672 511515
fax: 01672 513446 www.stonehealth.com
Paraloid B72:
Conservation Resources (UK) Ltd, Units 1, 2 and 4 Pony Road, Horspath Industrial Estate, Cowley, Oxford OX4 2RP. tel: 01865 747755
Paint system for bronze:
AKZO Nobel, Crown House, PO Box 37, Hollins Road, Darwen, Lancashire BB3 OBT.
tel: 01254 760760 fax: 01254 774414

Biography
Duncan Wilson specialized in conservation at the University of Manchester School of Architecture. After qualifying in 1979 he spent four and a half years with the Directorate of Ancient Monuments and Historic Buildings working at Hampton Court, Kensington Palace and buildings in the Royal Parks. He then joined the Winchester office of Purcell Miller, Tritton and Partners, working on the structural restoration of the Royal Pavilion, Brighton, for Brighton Borough Council, the repair of Cowdray Ruins, Midhurst, for Lord Cowdray, and the investigation phase of the Albert Memorial, London for the DoE/DNH. In 1993 he moved to the office of Peter Inskip and Peter Jenkins Architects Ltd, where he was job architect for the repair of Chastleton House, Oxfordshire (the National Trust), and where he worked on the construction phase of the repair of the Albert Memorial. He has since been engaged as job architect for the repair of Osborne House, Cowes, for English Heritage and for several ornamental gates in the Royal Parks. He is currently producing a scheme for restoring and reordering George Gilbert Scott's Chapel at Kings College, London.

6

The use of gold on architectural elements

Helen Hughes

Senior Architectural Paint Researcher

English Heritage, 23 Savile Row, London W1S 2ET

tel: 020 7935 3480 fax: 020 7935 6411 e-mail: helen.hughes@english-heritage.org.uk

Abstract

The application of gold on an architectural scale has always been a lavish expense that was intended to impress. This paper discusses the use of gold on a selection of architectural elements from the late sixteenth century to the twentieth century, with reference to research undertaken by English Heritage at Bolsover Castle, Audley End, Danson House, Osborne House, Leighton House, Windsor Castle and Buckingham Palace. In many buildings original gilding has survived unaltered. The survival of original decorative schemes provides valuable insight into period styles. It is therefore essential to investigate the history of these precious and rare surfaces before devising any conservation or redecoration scheme.

Key words

Architectural paint research, gilding, shell gold, Buckingham Palace, Windsor Castle, Bolsover Castle, Leighton House, Audley End

Introduction

The use of gold on an architectural scale has always been a lavish expense, an ostentatious display that was intended to impress. As an architectural paint researcher I am asked to discover the original appearance of historic decorative schemes [1]. Because rooms and other architectural elements such as gates, railings and bridges are routinely decorated it can be extremely difficult to determine the exact placement of the gilded decoration once it has been obliterated by later layers of paint. A sample taken from Battersea Bridge illustrates the complexity of the paint stratigraphy of a structure that has been repeatedly decorated for well over one hundred years (Fig 1).

Because of the tremendous cost, gilding on an architectural scale was not undertaken lightly. The list of rates for various decorative finishes in the 1776 *Builders Price-Book* reveals that painting once in oil cost two pence per yard, while gilding cost three shillings and nine pence per square foot. Gilding was an expensive exercise that was commissioned with the express intention of communicating the wealth and status of the client. It was therefore often specifically itemized in painters' bills and accounts, which otherwise tend to be very generalized.

Gilded decoration can be an important, readily identifiable, marker layer in a complex build-up of successive decorative schemes, and offers some point of certainty for the paint researcher otherwise lost in a maze of paint layers and sheaves of related documentary evidence. A distinctive piece of gilded decoration that forms part of the third decorative scheme carried out on Battersea Bridge can be dated to 1906, when, according to painters' accounts, 752 feet of gold leaf were applied to the bridge.

Determining specific decorative schemes from a cross-section can be an exacting task, especially where paint layers are very thin and similar schemes have been repeated. When examining complex cross-sections, layers of dirt can be important clues by which to distinguish topcoats from undercoats. However, it is usually correct to assume that a layer of gilding marks the final coat of most decorative schemes.

Elaborate gilded decoration was a massive financial investment, not to be overpainted arbitrarily, and in some cases never overpainted at all. The fact that a scheme was elaborately gilded often ensured its retention and survival, sometimes for several centuries. Where a small plain room might be redecorated on several occasions, owners tended to think twice before obliterating a major

Figure 1 Cross-section of paint stratigraphy from Battersea Bridge, London. © English Heritage

gilded decoration or undertaking the colossal cost of regilding very large rooms. Gold leaf, despite its thinness and vulnerability, is extremely hardwearing and does not tarnish. Original gilding was often retained while adjacent areas were redecorated. The survival of original gilded schemes such as that found on the sixteenth-century embossed decoration of the Wolsey Closet at Hampton Court offer a rare insight into the use of gold in architecture [2]. Other original gilded schemes have also been discovered in recent years. This paper examines several that have survived relatively unaltered.

The Pillar Parlour, Heaven Room and Elysium Room, Bolsover Castle

On 16 November 1618 the architect John Smythson stood in the Great Chamber of Theobalds and made a sketch of the panelling and the decorative scheme. Theobalds was the showpiece palace of James I, and had been proclaimed the 'handsomest house' in the land. It was famed for the splendour of its interiors, and was visited by everyone who was anyone, especially those looking for new ideas for decorating their own residences. The Great Chamber was sixty feet long and forty feet wide. It was described as 'One verry large spatious delightful room … being wainscotted round with carved wainscott of good oak and varnished and coloured of a liver colour [grained in imitation of walnut] and which gilded with gold' [3]. This amazing house was demolished in 1650, but we do have some clues about the appearance of the early gilded scheme. Smythson's sketch of the panelling carefully noted the placement of the gilding and the graining. The next year he recreated this scheme in the Pillar Parlour of Bolsover Castle [4]. Incredibly, it survived unaltered from *c*. 1620 until the twentieth century (Fig 2).

Samples taken from the panelling illustrate the rather robust application of the early scheme (Fig 3). The oak panelling was primed with limestone and oil. The frame was painted in a coarse black paint, mainly composed of coal. A bright yellow gold size was applied to the areas to be gilded. However, the placement of the gold was rather imprecise: it also became stuck to the coarse surface of the adjacent black paint, and most of the edges of the gold had to be defined with more black paint. The scheme aged very well and successive occupants felt no need to redecorate.

Two other rooms at Bolsover were decorated with an even more conspicuous display of wealth. The pair of small closets that lead off the master bedroom were fully panelled in oak. The panel moulding was gilded with gold leaf, but the panel beds of the Heaven Room were painted green and decorated with small Chinoiserie vignettes, which were painted in shell gold. Shell gold was prepared by mixing ground gold leaf with oil or size to form a paint. It is estimated that shell gold was four hundred times more expensive than conventional gold leaf. The panelling of the adjacent closet, the Elysium Room, was also decorated with shell gold, but in this room the panel beds had been decorated in imitation of a rich blue veined marble. The shell gold had been applied to suggest the veining pattern. The decoration of these rooms is a unique example of the use of shell gold on an architectural scale in a period when it was more commonly used to decorate small objects such as furniture or jewellery boxes.

The Saloon, Danson House

In 1760 the architect Robert Taylor was fitting out Danson House, Bexleyheath, for John Boyd, a successful London merchant. The octagonal saloon, with its lavishly gilded ceiling and cornice, is the climax to the

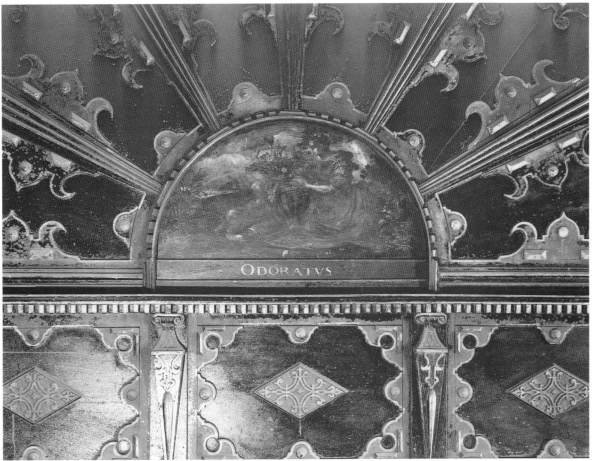

Figure 2 Detail from the interior of the Pillar Parlour, Bolsover Little Castle, Derbyshire, c. 1620. Photographed September 1958.
© Crown Copyright, National Monuments Record

Figure 3 Cross-section of gilded element from the Pillar Parlour, Bolsover Little Castle, Derbyshire, c. 1620. © English Heritage

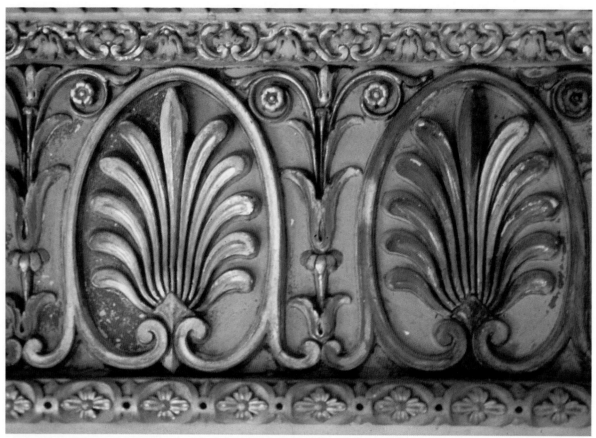

Figure 4 Detail of original gilding from the Saloon at Danson House, London. © *English Heritage*

suite of rooms on the ground floor. Research established that the ceiling cornice and all of the carved joinery had been delicately picked out with gold or 'party gilding' [parti-gilding], while the wall faces had been hung with fabric. Although the room had been redecorated on several occasions, and the gilding on the carved joinery overpainted, the original gilded decoration on the cornice and frieze had been retained. At the beginning of the eighteenth century solid gilding was employed, but later in the century parti-gilding, in which gold is only applied to edges and tips of ornament, became fashionable. William Chambers, one of the most eminent architects of the period, advised the fashion-conscious that their domestic decorations should be 'white & only heightened or streaked with gold for if it be Solid Gold it will look Clumsy' (quoted Bristow 1988). The survival of the original gilding on these elements within the room was extremely fortunate as it illustrates this more refined and delicate use of gold.

At Danson House English Heritage decided to re-create the original scheme in the Saloon while carefully conserving those elements that still retained their original gilding. Attempts to reveal the placement of the gilding on the joinery and ceiling bed were extremely arduous as it proved very difficult to remove the thick layers of overpaint. The existence of pristine gilding on the cornice was a valuable guide (Fig 4). In the course of the examination it was noted that the early decora-tors had cleaned their brushes on the surface of the wall. Traces of the yellow gold size and the Prussian blue

applied to the background of the frieze were daubed on the wall faces. These had been protected by the fabric that had subsequently been fixed over them. The traces of Prussian blue were a clue to the original colour of the frieze background, which was later re-created.

The Saloon, Audley End

Another remarkable survival of an early elaborate gilded scheme is that found in the Great Saloon at Audley End. The room had been extremely well documented – it was even recorded in a set of watercolours by the artist Columbani soon after its initial fitting out (*c.* 1770). At this date the ornate plasterwork and panelling was decorated plainly in a white oil paint. In 1784 the owner of the house, Sir John Griffen, was raised to the baronage and became Lord Howard de Walden. He began upgrading his house to match his new status. The next year the redecoration and lavish gilding of the Saloon was carried out at the cost of £223.4s.4d. Examination of paint samples removed from the room established that it had not undergone any major redeco-ration since the application of this gilded scheme – easily understandable, given the immense cost regilding such a large interior would have entailed. Elements such as skirtings, dado faces and dado rails had been partially regilded or touched-in at areas of wear or damage.

The surprising discovery that the scheme dated from 1785 prompted a reassessment of the redecoration propos-als for the room. The decision was made to surface clean and conserve the late eighteenth-century decorative

scheme, and simply to present the room in its existing condition. An investigation of decorative finishes in an adjacent suite of rooms fitted out by Robert Taylor revealed the extensive use of oil gilding in the large rooms, although certain architectural elements in a smaller boudoir were found originally to have been decorated with water gilding (which allowed for a high burnish).

The Grand Reception Room, Windsor Castle

A similar survival of original gilded decoration was discovered at Windsor Castle. The vast Grand Reception Room was fitted out in the 1820s. Since then it had been redecorated several times. Examination of samples from the various gilded elements within the room revealed that the original gilding on the ceiling and upper wall faces had been retained, while lower elements such as dado rails and skirtings, which had suffered knocks and abrasion, had been repeatedly regilded. Some elements had at least five or six layers of gilding (Fig 5).

Figure 5 Cross-section from dado panel moulding at Windsor Castle. © English Heritage

The Pavilion Wing, Osborne House

In another royal palace – Osborne House – this retention of the original gilded decoration can be found in all of the grand reception rooms and corridors. When

Queen Victoria and her family moved into Osborne House in the 1840s, the rooms were plainly painted in distemper finishes. The elaborate gilded and marbled schemes for the principal rooms, devised by Prince Albert and his advisor Ludwig Gruner, were not implemented until the 1850s. The accounts for the works itemize the decorations in great detail. Recent research has established that although the rooms were redecorated several times during Victoria's lifetime, all of the elaborate finishes – such as marbling, coloured details and gilding – were retained, and only the flat wall faces or plain white cornices and skirtings were repeatedly redecorated. Many of the rooms retain examples of original Victorian decorative finishes.

Buckingham Palace

The polychrome decoration that survives at Osborne gives some idea of the original appearance of the interiors of Buckingham Place, which were also decorated to Gruner's designs. However, unlike Osborne, where the major decorative schemes have survived largely unaltered, the 1850s polychrome schemes at Buckingham Palace have all been obliterated by later decoration in white and gold. Queen Victoria rarely used Buckingham Palace after the death of Albert and the palace had obviously fallen into a state of some neglect by the time her son, Edward VII, acceded to the throne. Edward saw its redecoration as 'a duty and a necessity'. It was also an opportunity to employ the French style he admired, with its use of white and gold. Many of the rooms were remodelled and redecorated *c.* 1907, and Edward's taste still dominates the decoration of Buckingham Palace's interiors today.

The Entrance Hall, Lord Leighton's House, Holland Park

Lord Leighton's house in Holland Park seems to be something of an exception to the rule that owners tend to retain and work around original gilding. The Entrance Hall to his house underwent constant change during his lifetime, and it seems that he was ceaselessly adjusting colours, adding additional elements as if he were working on a painting (Fig 6). The series of alterations is recorded in contemporary engravings of the room, in descriptions by those visiting the house, and in the paint samples taken from the room. Cross-sections of paint samples reveal the subtle change in the colours Leighton used for the capitals, which modulate over the years from a peacock green to a peacock blue. There is also a change in the type of leaf used to embellish the incised ornament. Early accounts describe a silver leaf, while later accounts suggest that the elements were picked out in gold.

Conclusion

Lord Leighton's repeated regilding of a room throughout a lifetime is unusual. In most cases gilded decorations on an architectural scale were executed once, then cherished and preserved, probably as much for financial

Figure 6 Archive photograph of the interior of the stair hall, Leighton House, London (date unknown). © Leighton House Museum, the Royal Borough of Kensington and Chelsea

reasons as aesthetic considerations. These examples highlight the fact that gold as a hard-wearing, but prized, decorative finish can and does survive for centuries. However, these precious surfaces can be lost in an instant by hasty overpainting. It is the duty of conservators to gain a thorough understanding of the decorative finishes and their significance before they embark on arbitrary regilding or stripping.

Notes

1. All of the architectural paint research referred to in this article was undertaken, or commissioned, by the Architectural Paint Research Unit of English Heritage. Details of the research undertaken at Bolsover Castle, Battersea Bridge, Audley End, Danson House, Osborne House, Leighton House, Windsor Castle and Buckingham Palace are recorded in unpublished reports held in the Architectural Paint Research Archive, English Heritage.

2. Paint samples removed from the Wolsey Closet of Hampton Court by kind permission of the Royal Palace Agency.

3. *The Parliamentary Survey of Theobalds* (1649), P. R. O. E317 Herts No.26.

4. *Panelling at Theobalds, Hertfordshire* (RIBA, Smythson Drawings Collection III/6).

Bibliography

Taylor I., 1776 *The Builders Price-Book*.
Bristow I. C., 1988 *Architectural Colour In British Interiors 1615–1840*, Yale University Press, 150.

Biography

Helen Hughes is a senior architectural paint researcher with English Heritage. She trained as an art historian and paintings conservator before beginning work with English Heritage over fifteen years ago. In 1986 she received a Winston Churchill Travelling Scholarship to research the reconstruction of historic houses in Poland and Russia. She is an Attingham Scholar (1995) and as a founder member of the Traditional Paint Forum she contributes to the planning and presentation of their annual conferences. She is also an accredited member of UKIC.

During her career she has conducted research on a wide range of historic interiors. She is actively involved with the training and the development of this discipline. She manages a database that details paint research carried out by English Heritage, and she is currently producing a handbook of case studies taken from this archive. She lectures widely, and is currently preparing a standards document for architectural paint research.

The restoration of gilding on panel paintings

Jill Dunkerton

Restorer

The National Gallery, Trafalgar Square, London WC2N 5DN

tel: 020 7747 2447 fax: 020 7747 2409 e-mail: jill.dunkerton@ng-london.org.uk

Abstract

When dealing with panel paintings the conservation of areas of gilding can never be considered in isolation. The condition of the gilding is likely to be determined, at least in part, by that of the support and ground. Gilding may form an integral part of the total image of a painting, whether as a gilded background or as decoration applied to painted areas using techniques such as mordant gilding and shell gold. This close relationship between paint and gilding affects the approach of picture restorers to the conservation and treatment of gilding on paintings, and especially the particular problems presented by the restoration of damaged areas of gilding. The ways in which different types of gilding may be damaged and the consequences of this damage for the image are considered and examples of different approaches to the restoration of gilding are discussed. Finally, the recent treatment at the National Gallery of a painting by Carlo Crivelli is presented as a case study.

Key words

Restoration, gilding, panel paintings, gesso, bole, gold leaf, tooling

At this conference it hardly needs to be said that gilding is of great importance to the many different types of object under discussion. Yet when a sculpture, whether of wood or stone or bronze, loses its gilding, it retains its value as an image. Similarly, a piece of furniture still functions as a table or chair, however impoverished in appearance. In the case of a panel painting, on the other hand, the gilding may well be integral to the image. It may even form the base for the whole image, as in the little *Virgin and Child* painted probably in the 1460s by Vincenzo Foppa, now in the Castello Sforzesco, Milan, where the entire surface has been covered with gold leaf and the figures painted over it.

Gilding can also be fundamental to the meaning of a picture. This may not be so evident when a painting is viewed under modern artificial light or the diffuse daylight of a picture gallery, but it was strikingly brought home to us at the National Gallery when the *Wilton Diptych*, painted by an unknown artist for Richard II in the late 1390s, was illuminated (with every imaginable precaution) by candlelight during the filming of the BBC television series, *Making Masterpieces*. The entire relationship between painted and gilded areas changed.

The rich and brilliant colours, which stand out when the painting is viewed in what we now regard as normal conditions, became subdued, as emphasis was transferred to the gleam and sparkle of the gilded areas. With the flicker of the candle flames the intricate, tooled decoration, all made with a simple dot punch, seemed to shimmer and itself almost to move. Small details such as the stippled gold ring held by Saint Edward the Confessor leapt into prominence, becoming part of the complex interplay of objects and gesture across the two halves of the diptych (Gordon 1993).

The original relationship between paint and gilding is inevitably compromised by the effects of time, damage and restoration. Some alterations that occur with age affect both equally – for example, the development of a network of cracks in the underlying gesso or chalk ground. The paint film develops its own finer craquelure within the larger network of gesso cracks, but visually the consequences are not as marked as those resulting from the fine fissures that form in even the best preserved areas of water gilding (caused, it is presumed, by the embrittlement with age of the glue or egg white binders in the bole layers). Areas of burnished water gilding, which once

had a dark gleam suggestive of solid gold, revert to a light-scattering surface more like that of the leaf in its unburnished state. This alters the equilibrium with painted areas – originally, it would seem, coated with glossy and saturating varnishes (Dunkerton, Kirby and White 1990). Furthermore, the contrast is reduced between the dark burnished leaf and any tooled decoration designed to catch incident light. Even more affected by this change are paintings, many of them from the German schools, in which dark and reflective burnished water gilding was set against areas of gold leaf laid over an oil mordant and therefore intended to be matt and light-scattering. The delicately tooled water gilt haloes in the National Gallery's panel of *Saints Matthew, Catherine of Alexandria and John the Evangelist* by Stephan Lochner, for example, no longer stand out from the matt gold of the mordant gilt patterned wall-hanging behind the saints.

The consequences of time can be seen on gilded areas of even the best preserved of paintings. We are concerned here more with the effects of damage, whether the outcome of accidents or of past restoration. Restorers of other artefacts may dispute this, but I suspect that paintings have a longer history of repeated interference and restoration than most other objects, and delicate water gilding is even more vulnerable than paint to the alarming abrasives and water-based cleaning materials recorded in many early treatises on picture cleaning. It is rare to find that the gilding is in good condition when the paint film has been eroded by past cleaning – indeed, I have not been able to come up with a single example in our collection.

In extreme instances the entire gilded background may have been destroyed and consequently replaced, as in the case of two side panels in the National Gallery from an altarpiece (*c.* 1470) by Zanobi Machiavelli. This regilding is likely to have taken place in the nineteenth century, with the revival of interest in so-called gold ground paintings. Count Giovanni Secco-Suardo, in his manual *Il Restauratore dei Dipinti*, first published in 1866, considered the replacement of gilded backgrounds to be too laborious and time-consuming for a restorer: since 'the time of a workman is worth less than that of an artist' such work should be assigned to a specialist gilder (Secco-Suardo 1927). Admittedly the painted areas of the Machiavelli panels are compromised by a degraded old varnish, but the appearance of the new gold is disconcerting, partly because of the lack of distressing, but also because of the 'cut-out' effect produced by laying the gold leaf up to the contours of the painted figures. The failure of a gold background to recede can be the first indication that a panel has been regilded.

Diagnostic methods of examination such as X-radiography are of limited value in determining whether any original gold survives underneath the regilding. Although the Machiavelli panels have never been properly investigated, the crack pattern suggests that some original gesso and gold may survive around the heads. However, it is possible that much of the gesso as well as the gold was scraped away and replaced, as on two of the National Gallery's twelve panels from the enormous

San Pier Maggiore Altarpiece, completed in 1371 by Jacopo di Cione and his workshop. These panels share with those by Machiavelli a common nineteenth-century provenance from the Lombardi–Baldi collection in Florence. When the San Pier Maggiore panels were cleaned a few years ago, nothing could be done for the regilded areas other than making improvements to the distressing and toning so that the new gold blended better with the original gold on the other panels.

While original gilding that has survived in a worn and damaged condition may be more acceptable to modern taste than the uniformly bright surfaces of the new gilding on the Machiavelli panels, badly abraded gold backgrounds can disturb the relationship between gilding and paint in different ways. This is especially the case with Italian paintings, for which strongly coloured orange-red boles were commonly used. It can be argued that the large amount of bole, exposed by wearing, on most of the National Gallery's panels by Sassetta from his Sansepolcro Altarpiece (commissioned in 1437), upsets the colour balance, clashing with the pale pinks of the architecture and giving unintended emphasis to the warmer colours in the paintings. On a northern panel, such as the *Saint Veronica with the Sudarium*, by the anonymous Cologne painter known as the Master of Saint Veronica, the very worn condition of the gilding is much less obtrusive – instead of a substantial layer of bright orange bole there is only an extremely thin preparatory layer, containing red-brown and black pigment, over the chalk ground (Campbell, Foister and Roy 1997).

Still more disturbing than overall abrasion, where the exposed bole is at least evenly distributed, are localized areas of damage with large and perhaps distinctively shaped areas of bright bole. These may stand out from otherwise well-preserved gilding, or may even be misread as part of the painted image. As anyone who has repaired gilding will know, it is practically impossible when working on a single flat plane to patch water gilding so that light will reflect from the surface in the same way as from the surrounding undamaged gilding. Nevertheless, an imperfect repair may be less distracting than the loss.

Traditional techniques of water gilding can be employed as long as the damage extends to the gesso as well as the gilding, and must therefore be filled with new gesso. However, if the original ground, together perhaps with patches of bole, is still present, then the principle of reversibility becomes a factor. New bole and gold leaf cannot be applied with water-based glues over a water-sensitive ground and bole without some risk to the surviving original materials, and future removal is likely to be hazardous. If this has been done in the past, it is often safer to leave the old restorations, perhaps improving their appearance by further distressing or toning. Surprisingly often, however, nineteenth-century repairs to gilding will dissolve off with the varnish and other restorations. When restoring this type of damage – for example on the water gilt haloes in the *Coronation of the Virgin* (Fig 1) by the early sixteenth-century German painter known as the Master of Cappenberg (now usually identified as Jan Baegert) –

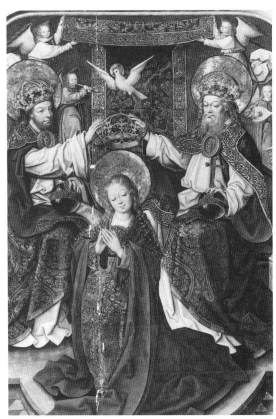

Figure 1 *Master of Cappenberg (Jan Baegert?),* The Coronation of the Virgin *(NG 263). Detail of the Virgin photographed after cleaning, before restoration.* © *National Gallery, London*

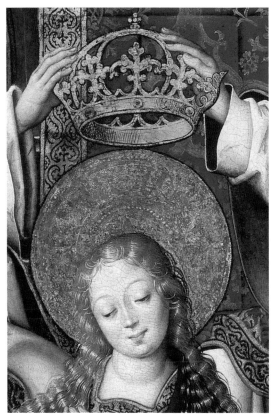

Figure 2 *Master of Cappenberg (Jan Baegert?),* The Coronation of the Virgin *(NG 263). Detail of the Virgin's water gilt halo after restoration of the losses with gold leaf applied to a mordant of Paraloid*® *B72.* © *National Gallery, London*

the disruptive effect of the losses can be diminished by applying small scraps of gold leaf to a mordant, which is essentially the retouching medium (at the National Gallery, usually Paraloid® B72) (Fig 2). This can also be combined with pigment to restore areas of missing bole. The surface of the Paraloid® B72 is made tacky (but not over softened or dissolved) by brushing it with an appropriate solvent mixture [1]. Once the medium has rehardened, the leaf can be slightly burnished, and then distressed and toned as necessary.

Paraloid® B72 can also be employed as a binder for powdered gold. This tends to scatter the light too much to be useful in the restoration of damaged water-gilding, and it is generally more appropriate for the matt finish of oil mordant gilding – for instance, the cloth-of-gold dress of the Virgin, the borders of the canopy and the mantles of Christ and God the Father in *The Coronation of the Virgin* (Fig 3). Gold powder applied in Paraloid® B72 or in gelatine is also commonly used for the restoration of damage to shell gold – it was used to repair the few small losses from Mantegna's beautifully executed and well-preserved panels of exemplary women in the National Gallery. Painted to suggest gilt-bronzes against polished marble backgrounds, the shell gold is used in place of white to shade and highlight the figures. Since any losses disrupt the modelling, they have been retouched in gold. However, where shell gold has been used more decoratively – on a halo or on the hem of a garment, for instance – losses and damage are often

left unrestored, as long as the absence of gold does not disturb or confuse our reading of the image. The same generally applies to decoration of this character executed with various types of mordant. On fifteenth-century Florentine tempera paintings, in particular, the lines and spots of mordant gilding have sometimes flaked away, pulling off with them the underlying tempera paint. The exposed gesso, yellowed with age and stained by later varnish, is often of a golden colour and, for such small-scale detail, serves remarkably well as a substitute for the missing gilding.

At the opposite end of the loss-scale are those pictures where a substantial part of the image is found to be missing, either because of past neglect or an accident. It has been suggested that the large losses on many of the surviving panels from Ugolino di Nerio's Santa Croce Altarpiece of about 1325 may be the result of parts of the altarpiece having toppled over (Muller 1994). The pinnacle panel of *Isaiah* is in a particularly fragmentary condition, and for many years was displayed in this state, with the missing areas filled in with a so-called neutral shade. Although no one shade can be neutral to all the colours surrounding a large loss (in the case of the Ugolino the red-brown mantle and the large areas of missing gold), neutrals became popular as a solution to the presentation of badly damaged paintings and frescoes in the 1950s and 1960s, largely perhaps as a reaction to the excessive repainting – and regilding – of pictures by nineteenth-century artist-restorers. In 1983, when the

Figure 3 Master of Cappenberg (Jan Baegert?), The Coronation of the Virgin *(NG 263). Detail of the Virgin's dress, executed with oil mordant gilding, after restoration of the losses with gold powder in Paraloid® B72. © National Gallery, London*

National Gallery acquired two more pinnacle panels from the Ugolino altarpiece, in better condition, it was decided that the presentation of the *Isaiah* was inconsistent with that of the other panels. It was therefore re-restored. The figure is only partially reconstructed since it is the replacement of the lost areas of gilding that does more to reduce the interference caused by the loss.

Other attempts to solve the problems of large losses include the development in Florence, following the flood of 1966, of codified methods of retouching, notably the technique of 'chromatic abstraction', in which a loss is filled with interlaced, usually non-directional strokes painted with the three primary colours and black, the proportions of the colours determined by (or 'abstracted' from) the colours of the areas surrounding the loss (Baldini 1978). The technique has been applied to losses from gold as well as paint. The textbook method is to apply first the yellow (a transparent yellow such as Indian yellow), then red and finally a transparent green (breaking the primary colour rule) (Casazza 1981). The aim is to achieve something of the vibrancy of the gilding surrounding the area of loss, although any sense of the reflective properties of gold is, of course, absent. The technique, with various modifications, has

been used extensively to restore missing gilding on sculpture and frames as well as paintings. However, in recent years restorers in Italy have come to question its validity, partly because of difficulties in applying it with the consistency of approach that its logic demands, but principally because, for the viewer, and particularly the non-specialist, the restoration has its own fascination, drawing attention to itself and competing for attention with the surviving parts of the original work of art.

The possibility of using one of these very visible methods of restoration was never seriously considered in planning the recent treatment of the *Dead Christ supported by Two Angels* (Fig 4), the central upper tier panel of a now partially dismembered polyptych painted by Carlo Crivelli in about 1475 for the church of San Francesco in Montefiore dell'Aso, near Fermo. Perhaps as the result of an accident, or possibly through the formation of huge blisters, the painting has suffered two large losses: an area on the lower edge, and, more importantly, a large triangular area comprising the whole left side of Christ's head, the shoulder and the lower part of the profile of the angel to his left, and most of the gilding between them. The painting had been restored before it entered the Collection in 1859, probably while it was on the art

Figure 4 Carlo Crivelli, The Dead Christ supported by two Angels *(NG 602). Before treatment.* © *National Gallery, London*

market in Rome. The restoration of the painted areas seems to have been skilful – Otto Mündler, the Gallery's travelling agent, apparently failed to notice the extent of the damage, describing the 'state of preservation [as] excellent' – and it was only with time that the retouchings discoloured to such a disfiguring extent, especially on the face of the angel. The restoration of the gilding can never have been as satisfactory, for the bole was poorly matched and the distressing was perfunctory. Additional, much brighter gilding had been applied around the curve of the arch and along the right edge, probably in 1859 when the painting arrived at the National Gallery.

Since it was only the deterioration of the old restorations – and the discoloration of the nineteenth-century varnish – that led to the decision to clean the painting,

their removal and replacement with a very visible method of restoration would result in little gain from the point of view of the appearance of the picture. The decision to reconstruct the losses, at least to the extent of the earlier restoration, and possibly to copy them exactly, was taken before cleaning began. Further justification came from the discovery that underneath the discoloured varnish most of the painting had survived in quite exceptional condition, complete with a barely discoloured fifteenth-century varnish of sandarac and walnut oil, applied, as stipulated by Cennino Cennini, to the painted areas alone (Dunkerton and White 2000). Most of the gilding was also in a remarkably good state. It was evident that, in order to avoid too jarring a discrepancy between the original painting and the losses, the restoration, including the

Figure 5 Carlo Crivelli, The Dead Christ supported by two Angels *(NG 602). Showing the tooling of the new gold with, as a guide, a print-out of the digital scan made before the underdrawing of the reconstructed area was covered with bole and gold leaf.* © *National Gallery, London*

gilding, needed to achieve a high level of deception, at least for casual viewing of the painting in gallery conditions. Alerted by the text of the label, closer inspection will reveal the extent of the losses – the new gesso has deliberately been left completely smooth and flat, with no attempt to imitate the distortions to the original ground caused by cracking and cupping.

Just as when the painting was executed, every stage in the reconstruction of the missing areas had to be worked out in advance. The discovery of significant fragments of original paint buried beneath the old restoration meant that some adjustments to the contours of the reconstructed areas were necessary. Trials were made in watercolour on full-scale images of the painting printed from digital scans and agreement was reached as to the most satisfactory design. This was then drawn onto the new gesso, including the tooled patterns of the haloes, the punched motifs following the same sequence as in the surviving parts of the original. A bole was mixed to match the light orange-red of the original gilding [2] and applied in a glue medium. This was burnished before the laying of the gold leaf, but the gold leaf itself (double thickness 23¼ carat Italian gold) was mostly left unburnished. However, to imitate the effects of the usual top-lighting on the slight cupping of the original ground, artificial cracks were lightly incised into the new flat gesso and a narrow band of gold immediately below each 'crack' was darkened in tone by burnishing. Crivelli achieved the assorted patterns on

the haloes by combining in different permutations just two sizes of round-ended indenting punches, together with a horseshoe-shaped motif, sometimes punched twice to form an irregular circle or oval, and a small stippling or graining tool. These could therefore be imitated by modifying existing punching tools. In executing the tooling, it was important not to be too accurate and careful, thereby retaining some of the freedom and the occasional imprecision that characterizes the original. Guidance was provided by a print of a digital scan of the drawing of the halo made on the gesso before it had been covered with bole (Fig 5).

The level of distressing and toning of the new gold was determined by the slightly damaged area of original gilding to the right of the large loss. This damage was, in a sense, fortunate – had all the gilding been in the condition of that on the left-hand side of the picture, it would have been considerably more difficult to disguise the junction between new gold and old. The toning was carried out first with watercolours and then adjusted with pigments in Paraloid® B72 once the whole painting had received a first brush-coat of varnish. Following the reconstruction of the painted areas, a final spray varnish was applied. For obvious practical reasons it is difficult to avoid varnishing the gilding on panel paintings (invariably it has been varnished before), and the procedure can be justified by the protection afforded by the coating.

The restoration of Crivelli's panel presented exceptional challenges, not least the need to aspire to the

Figure 6 Carlo Crivelli, The Dead Christ supported by two Angels *(NG 602). After treatment. © National Gallery, London*

craftsmanship of the original work. The reduction of the distracting effects of the damage means that the viewer is better able to enjoy the touching and beautifully painted original parts of the picture (Fig 6). Equally important is the fact that, by restoring a degree of unity to the whole image, it becomes possible once more to appreciate the interplay between paint and gold, and the way that the sculptural figures project while at the same time forming fascinating shapes and patterns as their contours meet the gilding of the background.

Acknowledgements

The gold leaf was laid for me by Clare Keller of the National Gallery Framing Department in a fraction of the time that it would have taken an out-of-practice paintings conservator. The punching tools were found and adapted by John England, Head of the Framing Department.

Notes

1. I find that a small amount of propan-2-ol or IMS added to white spirit works well.

2. 'French red' modified with yellow bole and intensified with a small amount of cadmium orange and Indian yellow.

Bibliography

Baldini U., 1978 *Teoria del restauro e unità di metodologia*, Florence, Nardini Editore.

Bomford D., Dunkerton J., Gordon D. and Roy, A., 1989 *Art in the Making: Italian Painting before 1400*, London, National Gallery Publications.

Campbell L., Foister S. and Roy A. (eds) 1997, 'Early Northern European Painting', *National Gallery Technical Bulletin*, 18.

Casazza O., 1981 *Il restauro pittorico nell' unità di metodologia*, Florence, Nardini Editore.

Dunkerton J., Kirby J. and White R., 1990 'Varnish and Early Italian Tempera Paintings' in *Cleaning, Retouching and Coatings*, Preprints of the Contributions to the Brussels Conference of the International Institute for Conservation, 3–7 September, 63–9.

Dunkerton J. and White R., 2000 'The Discovery and Identification of an Original Varnish on a Panel by Carlo Crivelli' in *National Gallery Technical Bulletin*, 21, 70–6.

Gordon D., 1993 *Making and Meaning: The Wilton Diptych*, London, National Gallery Publications.

Muller N., 1994 'Reflections on Ugolino di Nerio's Santa Croce polyptych' in *Zeitschrift für Kunstgeschichte*, 57, I, 45–74.

Secco-Suardo G., 1927 (fourth edition, first published 1866), *Il restauratore dei dipinti*, Milan, Ulrico Hoepli.

Materials and equipment

Paraloid® B72 (Rohm and Haas) ethyl methacrylate and methyl acrylate copolymer:
Rohm and Haas (UK), Lennig House, 2 Mason's Avenue, Croydon CR9 3NB.
'French Red' (International Gilders' Suppliers, Ontario):
Double thickness 23½ carat Italian gold leaf and gold powder:
Stuart R. Stevenson, 68 Clerkenwell Road, London EC1M 5QA.
Artists' watercolours:
Windsor and Newton, 51 Rathbone Place, London W1P 1AB.

Biography

Jill Dunkerton studied Fine Art at Winchester and Goldsmiths' Schools of Art, History of Art (MA) at the Courtauld Institute, and paintings conservation at the Tate Gallery and Courtauld Institute. She has worked as a restorer at the National Gallery since 1980 and is the author or co-author of many publications, including *Art in the Making: Italian Painting before 1400, Giotto to Dürer: Early Renaissance Painting in the National Gallery*, and, most recently, *Dürer to Veronese: Sixteenth-Century Painting in the National Gallery*.

Framing at the National Gallery

Louisa Davey

Frame Conservation Department, The National Gallery

The National Gallery, Trafalgar Square, London WC2N 5DN

tel: 0207 747 2846 fax: 0207 747 2500 e-mail: louisa.davey@ng-london.org.uk

Abstract

The Frame Conservation Department at the National Gallery is responsible for conserving and repairing almost 3,000 frames. Most of the frames surround the paintings on display, but a number of them are stored in-house. The department works to an exacting schedule to meet the many and varied demands of the gallery's collection. Frames are monitored in order to check that the conditions are suitable for their long-term conservation. The frames are treated as artefacts in their own right while also fulfilling a role as the protective surroundings to the paintings.

There is a constant flow of picture loans to and from the gallery and all frames are assessed for condition on departure and return. When a frame is considered too important or too fragile to travel, a reproduction frame is made to replace it. Very few of the paintings in the collection have retained their original frames. One of the department's main priorities is to locate and replace frames with authentic ones wherever possible.

Key words

Turner, Ruisdael, framing, frame archive, reproduction, National Gallery, gilding, *repareur*

Our work at the National Gallery frame department is based on a programme of conservation that takes account both of the gilded and decorative surface of a frame, and its wooden base. A major part of our work involves selecting frames to reframe pictures, and many of these require conservation or restoration work. There are various reasons why a picture may undergo reframing. In the main, static collection itself there are paintings that are still considered, on aesthetic and/or historical grounds, to be unsuitably framed. Alternatively, a newly acquired painting may arrive without a frame or with one that is felt to be inappropriate. As a general rule the gallery policy is to display a painting in a frame contemporary to the period in which it was painted. When the decision is taken to reframe a work the origins of the painting are carefully considered.

Perfect fits

Rest on the Flight into Egypt, painted by Pierre Patel in 1650, was for many years displayed in an English, Queen-Anne style reproduction frame with a distinctive gad-rooned knull. This frame was replaced in 1999 with a more suitable, French neo-classical carved oak frame. The frame had been in the gallery frame store for at least twenty-five years, with no record of how it came to be there. (It must be noted here that detailed records of frame movements around the National Gallery only began fairly recently.) The frame had been stripped of all its original gilding and dismantled so that it could be stored in four sections. It was found to be a perfect fit for the Patel – a rare instance of an aesthetically appropriate frame accomodating a painting without alteration. Once the fit of the frame with the painting had been established the frame was photographed and recorded in its original state, stripped of gold and gesso. Restoration commenced with the recarving of areas of missing ornament, followed by the rejoining of the separate sections of the frame. Once rejoining was complete the frame was regessoed and repaired using the traditional French methods of finishing the gesso with cutting irons (*repareur*). The newly gilded frame was toned to age its appearance, using both the painting and the other frames in the room where it now hangs as guides to the depth of tone required.

Reproduction frames

Another aspect of reframing is the making of reproduction frames. A North Italian cassetta, made *c.* 1490, and featuring a distinctive punched 'Greek key' frieze, with

roundels in each corner, was thought to be an ideal frame for Palma Vecchio's *Portrait of a Poet* (painted *c.* 1516). However, although the frame was close to the painting in size, it was not quite close enough. With nothing else available at the time it was decided to make a reproduction using the period frame as a model. The reproduction was built from yellow pine (although the original was constructed in poplar, the traditional wood of Italian frames), joined with half laps, hand sawn and then moulded with the help of moulding planes. After gessoing, the deep red bole of the old frame was faithfully copied. Then, after gilding and burnishing, the decorative 'Greek key' frieze was punched into the flat of the cassetta. The beautiful and undamaged patina of the old cassetta was closely reproduced at the toning stage as it was of a colour and texture that complemented the painting very well. Much of the colour of the old frame came from the deep red of the bole showing through the worn gold. The gold leaf of the new frame was, therefore, heavily abraded in order to bring the colour of the bole through. Several layers of a dark tone were then applied to reproduce an aged patina.

De-framing Turner

A major project completed recently was the reframing of the gallery's collection of paintings by Turner. During the 1960s Turner's paintings were all removed from their original Victorian frames and uniformly framed in plain, reverse section mouldings.

In the last five years *The Fighting Temeraire*, *The Evening Star* and *Rain, Steam and Speed* have all been removed from plain moulded frames and reframed in period frames, continuing a reversal initiated in the 1980s, when Turner's *Dido Building Carthage* and *Sun Rising Through Vapour* were also removed from the same type of plain mouldings.

Figure 1 shows three of Turner's paintings on display in 1956, in their Victorian frames. The National Gallery archives hold records of several discussions about the issue of the Turner frames and the subsequent reframing:

> De-framing Turner 5 Turners in room XV
> have been re-framed in modern reverse
> mouldings, which have been toned or
> covered in material matching the wall
> covering by the department.
> Work in hand March 65.
> [from Frame Department work schedule,
> 1965–6]

Figure 2 shows Turner's *Rain, Steam and Speed* in the plain moulding that was adopted for all the Turner paintings. The wall covering referred to in the above

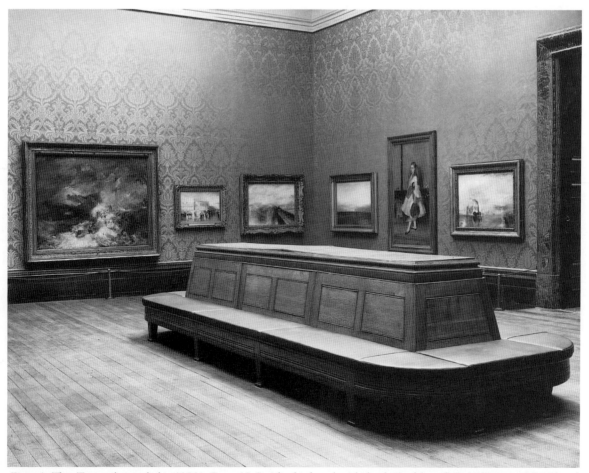

Figure 1 Three Turners photographed in 1956 in Room 15. Straight ahead, on the right-hand side of the wall, Rain, Steam and Speed, *and, on the right-hand wall,* The Evening Star *and* The Fighting Temeraire, *either side of Whistler's* Portrait of a Girl. © *National Gallery, London*

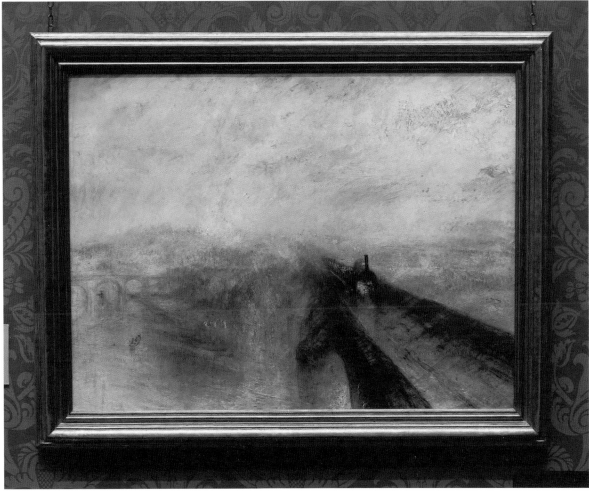

Figure 2 Turner's Rain, Steam and Speed *in 1960s frame, with simple moulding.* © *National Gallery, London*

quote would have been a beige material. The fashion in the 1960s was to emphasize paintings with the use of modest, unobtrusive frames and wall colours:

> Turner's works lost their gilded hollow, 'Morland' or laurel frames, often ending in neutral greyish 1960s mouldings with inner hessian slips.
> (Mitchell and Roberts, 1996)

Figure 2 also shows the present wall covering of green damask in the English room at the National Gallery. The damask is a revival of the wall coverings that may have been used in the Victorian era when the gallery was first opened. The illustration demonstrates how the damask wall covering works against the simplicity of the frame – clearly, a plain wall covering would be more suitable.

Within three years of the completion of the 1960s reframe, various problems arose relating to whether the modern frames 'worked':

> 6th June 1968
> Mr Keswick [Chairman of the Board of Trustees] raised the question of the new Turner frames which he found unsatisfactory ... the keeper had agreed that the old frames should be put back on the pictures in question for the July meeting. The board would then be able to see the room again and consider the matter.
> [From the minutes of the meeting of the Board of Trustees]

After the Board had seen the paintings in their old frames they met again to discuss the the various problems:

> 4th July 1968
> ... They saw the three pictures by Turner on the east wall exhibited in their gold frames. The keeper explained that the new frame for 'The Evening Star' had been retained for comparative purposes and that he had had this considerably darkened in tone. A number of trustees expressed their preference for some style of old frame, though not wishing to retain the old Victorian frames as such. The keeper would take the necessary steps to meet these wishes.
> [ibid.]

One reason for reframing may have been that the Victorian frames were in poor condition. This factor,

combined with the pressure of contemporary taste in favour of modernization, meant that, in spite of the discussions over the unsuitability of the plain mouldings, they remained around the Turners until the 1980s.

At the beginning of the 1980s new staff in the National Gallery frame department recognized a large, Victorian, laurel-leaf frame in the frame store as the original for Turner's *Dido Building Carthage*, and suggested to the Board of Trustees that the frame be restored and returned to the painting, arguing the case for the historical significance of such a frame. Minutes from the Board's meetings during 1980 briefly mention the past difficulties arising from the plain mouldings:

> Sir Michael Levy says this frame (plain moulding) was Legge's design [Legge was a frame maker employed by the gallery]. It was first tried in silver but did not 'work' and was redone in gold. It may have been in a heavy Victorian frame before we reframed in 1968.

And another Board of Trustees note during 1980, referring to the 1960s frame for Turner's *The Fighting Temeraire*, observed

> I agree about the colour but have always shied away from doing anything as I know Ken. Clark was particularly proud of this.

Once agreement was reached about reuniting the frame with the painting, work could begin on restoring the frame, which was in very poor condition. The gesso had suffered from damp; it was powdery and, in some places,

lost altogether. The gold was deeply ingrained with dirt. Also, very significantly, the frame had been subject to a major alteration sometime between the date of its original construction and the 1920s. It had been altered to accommodate a pane of glass, and the sight edge of the frame had been removed and replaced with a plain gilded slip, which was glazed and fitted as a front opening door. The restoration included removing the plain glazed slip in order to replace the sight edge. The work also included strengthening the mitres, and, lastly, because so much of the original gold was lost, entirely regilding. *Dido Building Carthage* and its restored frame are now on permanent display between two paintings by Claude, in accordance with the wishes laid out by Turner in his will (the composition and mood of this picture was intended as a conscious homage to the work of Claude.)

Vandalism

Almost all the pictures in the gallery were glazed between 1850 and 1930, often with the aim of protecting them against pollution: the rate at which gold darkened was cited in enquiries into the need to protect paintings with glass, which had been held early in the 1850s. Various instances of vandalism also emphasized the need for glazing. In 1913 the canvas of *The Rokeby Venus* was slashed. A letter to the gallery at the time gives a list of paintings that were glazed when it was felt they too might be at risk from vandalism (Fig 3).

Some of those appearing on the list, such as the four Ruisdaels (the last four listed), can be found in the reserve collection. They have remained unchanged since being altered for glass in 1914. One of the frames, for Ruisdael's

Figure 3 Letter concerning frames requiring glazing for protection against vandalism. © National Gallery, London

Figure 4 Corner of frame for Ruisdael's Skirt of a Forest, *showing the joint between the sanded flat and the cushioned, ogee moulding.* © *National Gallery, London*

Skirt of a Forest, is shown here (Fig 4). The method used for adapting antique frames for glazing was to cut out the inner section of the frame. The cut-out section was then fitted with glass and relocated in the frame, kept in place with pins and thumbscrews. The painting sat behind a second rebate, and the back of the frame was built up to accommodate the extra depth. Interestingly, this frame has also been reduced in size by removing timber at the mitres, and through the profile at two points on each side of the frame. In the illustration a hairline crack is visible where one of the cuts was made. Aside from this alteration the frame has also been over gilded and painted with a coat of gesso, which has muddied the once-detailed *repareur* crosshatching. The over-working of the surface has entirely altered the appearance of this provincial, Louis XIV, carved oak frame.

Reframing Turner

After the return of *Dido Building Carthage* to its original frame at the beginning of the 1980s it was decided that all the Turners should be reframed authentically in Victorian frames. The 1960s framing experiment would finally be abandoned.

Research to find period frames for the three Turners still remaining in the 1960s mouldings began in 1994. For *The Fighting Temeraire* a French neo-classical frame was purchased, with fluted hollow and acanthus leaf corners. It is a fine example of a neo-classical frame and complements the picture very well.

A second neo-classical frame, of English origins, was purchased for *The Evening Star*. Although this frame is not of quite the exceptional quality of the 'Temeraire' replacement, the style and colour worked pleasingly with the picture. However, the sight opening was too small for the painting. After careful consideration it was decided to dismantle the frame and fit wood at the mitres, thus

extending the frame at all sides, in order to fit the painting. Although this meant altering the frame from its original format, the work was considered reversible: the frame could easily be returned to its original size without loss (Fig. 5). The mitres were rejoined after implanting wood extensions, with new tapered keys. The middle section of the corner acanthus leaf ornament was remodelled, joining the original edges of the leaf ornament with a new sculpted stem. The corners were gilded and toned. Other gilding losses were repaired, but because the patina of the frame accorded so well with the picture and the other frames in the room no cleaning was carried out.

The third and final painting remaining in a 1960s frame, *Rain, Steam and Speed* (Fig 1), was finally reframed in 1999, again with a neo-classical style frame, though not quite of the quality of the first two frames purchased. The poor condition of this frame when purchased meant the frame had to be regilded. The new gold was distressed and toned to age it in keeping with the other neo-classical frames. The toning was applied in several layers separated by an acrylic varnish. With this frame for *Rain, Steam and Speed* the reframing of the Turners was complete (Fig 6).

The gallery is fortunate to be able to display some original Turner frames alongside these period replacement frames. Turner's *Dutch Boats in a Gale* – sometimes called the *Bridgewater Sea Piece* – was commissioned by Francis Egerton, third Duke of Bridgewater, as a pendent to *A Rising Gale* by William Van der Velde the younger (a similar composition, but in reverse, and now in the Toledo Museum of Art). Turner was paid 250 guineas for the picture and tried unsuccessfully to obtain a further 20 guineas for the frame, in which it still hangs. The frame is a very fine example of the English neo-classical style, with a carved acanthus leaf hollow and reeded knull. The oil gilding is also original.

Figure 5 Corner of frame for Turner's The Evening Star *during restoration, showing an extended section.*
© *National Gallery, London*

artefacts in their own right. The question will always be present as to whether, in the future, a new interpretation of framing will require the Turners to return to simple plain mouldings, or to frames that have a non-demonstrative relationship with, and a minimal impact on, the viewing of, the paintings they surround. Reinterpretation of framing is to be expected: changes in fashion and changes of ownership are just two of the many reasons that lead to frame re-thinks. With this in mind one of our main aims as a conservation department is to complete our frame archive. The identity and location of frames, their conservation histories, and their relationships to paintings, can all be recorded for future reference. This research will, it is hoped, ultimately lead to a greater understanding of historical framing and the framing decisions of an artist such as Turner.

The framing and conservation issues discussed here will, I hope, give an overview of how the National Gallery frame department approaches frame conservation, and some idea of the steps we take to preserve the frames both as functional objects and as historical

Acknowledgements

I would like to thank John England, Head of the Frame Department, for providing me with information about the condition of the Turner frames, and Sarah Perry, for her research into the National Gallery Archives.

Figure 6 Four Turners, three newly framed in neo-classical frames (left to right: The Fighting Temeraire, The Evening Star, Rain, Steam and Speed*).* Margate from the Sea *hangs on the far right in a 'Morland Hollow' period frame, possibly original, though of mediocre quality.* © *National Gallery, London*

References

Mitchell P. and Roberts L., 1996, *A History of European Picture Frames*, London, Merrell Holbertson, 14.

Materials
Fers a reparer (gilding irons):
Wigand Drescher, Engelhardstr. 10, D-90762 Furth, Germany. tel: +49 (0)911 740 8620
fax: +49 (0)911 740 8625
Synthetic varnishes (from Lascaux)
A. P. Fitzpatrick, Fine Art Materials, 142 Cambridge Heath Road, London E1 5QJ. tel: 0207 790 0884
fax: 0207 790 0885

Biography
Louisa Davey has an honours degree in Sculpture from Manchester Polytechnic and a post-graduate diploma in Conservation of Fine Art from the City and Guilds of London Art School. She was a frame restorer at Arnold Wiggins and Sons. She has worked as a conservator at the National Gallery for five years.

The management of frame conservation in National Trust houses

Sarah Staniforth

Adviser on Paintings Conservation and Environmental Control

The National Trust, 36 Queen Anne's Gate, London SW1H 9AS

tel: 020 7447 6524 fax: 020 7447 6540

email: lhbses@smtp.ntrust.org.uk website: www.nationaltrust.org.uk

Abstract

There are nearly 10,000 framed paintings in 120 houses owned by the National Trust in England, Wales and Northern Ireland. The majority of these frames are gilded. In addition there are gilded frames on mirrors and works of art on paper. The care of these frames is based on good preventive conservation strategies. These include keeping relative humidity levels as constant as possible, training staff in the handling and day-to-day care of frames, providing suitable methods for hanging frames, and also for storing them when they have to be taken down for building work.

Remedial conservation treatment is carried out in the houses for minor treatments, or in conservators' studios for major treatments. If the latter involves a change in appearance then careful consideration is given to the relationship between the frame, what it surrounds and the rest of the room. It is hoped to develop the planning of remedial frame conservation along the same lines as painting conservation. However, this is hampered by lack of records about treatment of frames in the past. What is a reasonable cycle for treatments such as cleaning? How often are major treatments such as consolidation likely to be needed? How much difference will good preventive conservation make?

The National Trust has spent the past 20 years improving the documentation of its frames, first by making a curatorial survey, and then a condition survey. This documentation is now largely completed and will greatly help with the future planning of frame conservation.

Key words

Management, frames, economics, National Trust

Introduction

This paper is written as a pair with one on the management of painting conservation in National Trust houses (Staniforth 1996). It outlines the challenges in caring for a collection of over 10,000 gilded frames surrounding paintings, mirrors and works of art on paper in 120 historic houses in England, Wales and Northern Ireland. The National Trust does not employ advisers on frame conservation, so the advisers on paintings conservation are responsible for the management of frame conservation, with the advisers on pictures and sculpture providing curatorial advice.

The approach adopted by the National Trust combines high standards of preventive conservation and housekeeping with a realistic programme of remedial conservation based on an understanding of the frequency of various forms of treatment. As all remedial conservation is carried out by freelance conservators, knowledge of costs for treatments is essential. A figure for the annual care budget for a painting has been calculated using knowledge of the length of treatment cycles and average costs (Staniforth 1996). This was £19 per painting, per year, in 1999. At present we do not have enough information about cycles of treatment, nor of average costs, to calculate a similar figure for frame conservation.

Preventive conservation

Relative humidity control and integrated pest management are the most important factors to consider in frame conservation. Invariably, pest infestations occur in houses with high relative humidity levels, so these two agents of deterioration are linked. Much has been written on methods of environmental control used in National Trust houses (Sandwith and Stainton 1993; Staniforth, Hayes and Bullock 1994), and, along with good housekeeping practice, these contribute significantly to the care of gilded frames. The National Trust has carried out a research project to develop a methodology for the anoxic treatment of paintings and frames on site. This 'greener' method of treating insect infestations avoids the use of insecticides that may pollute the environment or harm other wildlife in a building (Caldwell 1998a). Another risk to which frames are constantly exposed is physical damage. This can happen whenever they are handled and may also result from inadvertent impact while they are hanging.

Frame hanging and handling

National Trust house staff are trained to handle frames correctly. Initial training in methods of carrying and storing frames is carried out at the Housekeeping Study Days, which all new members of house staff attend. This is built on during Emergency Procedures Training, when methods of hanging frames are considered with the aim of making them easier to remove. For example, if frames were previously hung by hooks into chains, we have replaced the hooks near the top of the frames with rings and moved the hooks to the bottom. The chain is lengthened, passed through the rings and fixed onto the hook. The hooks are then in reach from the ground and can be disengaged from the chain without having to climb a ladder.

Frames have to leave houses to be transported to conservators' studios and for loan exhibitions. For journeys within the UK the frames are usually soft wrapped. The frame is wrapped in a sealed polyethylene parcel and the corners are cushioned using Bubblewrap®. Delicate gilding is first protected with acid-free tissue. Frames with particularly ornate decoration, and all frames being lent overseas, are packed in cases with suitable cushioning material after first being wrapped in polyethylene.

Building repairs and works to improve services mean that houses have to be emptied of their contents. This provides an opportunity to put training into practice and salvage teams, as well as house staff, usually help with the taking down and storage of frames. We have to create temporary stores for frames. This can be done quite cheaply by building racks from low formaldehyde medium density fibreboard (MDF) lined with Plastazote® cushioning. Simple frames can be separated with acid-free card or Bubblewrap® cushions, and those with more ornate mouldings can be separated with 'T'

and 'U' bars [1] that are thick enough to prevent the mouldings from touching adjacent frames.

Housekeeping

Day-to-day care of frames is the responsibility of house staff. The frames are usually only dusted once a year as part of winter cleaning – however, the dust levels vary from house to house. Recent research shows that the amount of dust at eye level is closely related to visitor numbers (Yoon and Brimblecombe 2000a; Yoon and Brimblecombe 2000b), so frames in houses with higher visitor numbers may need more frequent attention. The dust is removed using pony-hair brushes and collected in the nozzle of a vacuum cleaner. House staff are trained at the Housekeeping Study Days and by Regional Conservators. Frames with flaking gilding are identified by conservators when they survey the collections and are not dusted until remedial conservation treatment has been carried out. The annual attention given to each frame is also an opportunity for careful inspection to detect early signs of instability and insect attack. Pieces of moulding that become detached are collected and placed in a labelled envelope in the 'bit box' for replacement by frame conservators.

It is interesting how National Trust practice today reflects traditional practice in country houses. A study of the domestic care of paintings in English country houses (Rose 1998) discovered information about domestic care of frames as well. The advice given ranges from extreme caution:

> Never to dust pictures, nor the frames or
> anything that has a gilt edge (Whatman 1776)

To caution:

> She must not apply a brush or broom to any
> pictures or frames, but only blow the dust
> off with a pair of bellows; though she may
> now and then dust them with a very soft
> duster, or piece of flannel… (Anon 1820)

To what is almost contemporary practice:

> Looking glass, and picture frames should
> be brushed with a soft painter's brush
> (Anon 1800)

There are, however, some recommendations that should be treated with the utmost suspicion!

> To clean your frames. First rince them well
> with cold Water till all the Dirt and Dust is
> off; then take hot Water and Sope, make a
> very strong Lather and with a Sponge rub
> them well till quite Clean, and set them to
> dry (Glasse 1760)

Surveys and documentation

Although records of painting conservation are not extensive they can sometimes be found in the archives of country houses. Historic records of frame conservation are, however, non-existent, which is a little surprising in view of some of the major interventions that have clearly taken place – for example, where silvered frames have been regilded.

The first step in conservation planning is to have good condition records, treatment proposals and estimates for the time involved in carrying out remedial treatment. The National Trust had to take one step back in beginning this work, since it had no proper curatorial record of its collection of frames before Hermione Sandwith began a systematic survey in 1982 (Sandwith 1985). This was initially undertaken by Paul Levi, assisted by Tim Newberry, and recorded the date and type of frame, its method of manufacture, as well as a brief assessment of its condition. Profiles were drawn of the mouldings and carvings and measurements taken. The frames were also photographed.

Once we had a record of what frames there were it was possible to build up conservation records. This has been carried out by a number of frame conservators – principally Peter Thuring and Jock Hopson – and the data has been collated by Victoria Boyer. This survey is now complete for painting frames and is underway for mirrors and works of art on paper. Summary sheets are prepared for each house listing the number of frames requiring treatment and indicating whether this treatment can be carried out at the house or in the studio.

Frame conservation treatment *in situ*

If possible, frames are treated in the houses rather than in conservators' studios [2]. This minimizes the handling that they receive. Some treatment is possible while the frames hang on the walls, including condition survey and documentation, dusting of front surface, retouching surface losses and re-adhering loose or detached ornaments. Frames have to be taken down for more extensive treatment and this provides a training opportunity for the house staff under the supervision of the conservator. This conservation work may include structural repairs of splits and open joins, woodworm treatment, consolidating separating surface layers, re-adhering detached carved and applied ornaments, reproducing missing applied composition ornament, gesso and gilding infills, retouching, surface coating and recoating back edges with ochre. The extent of the work undertaken is dependent on the time available. On average, between twenty and twenty-five frames can be treated during an *in situ* visit lasting one week. When a frame requires extensive conservation work it is taken to a frame conservator's studio. We are increasingly using the absence of objects from houses during the open season

as an opportunity for increasing the visitor's awareness of conservation work, by providing information about the type of treatment being undertaken. This has the added advantage of spreading the conservator's workload through the year rather than concentrating it in the closed season from November to March.

Conservation framing and backing

Although conservation framing is principally a preventive conservation measure that benefits paintings, some aspects also protect the frame. The most obvious of these is the use of screwed plates as a fixing method for the painting, rather than nails. The vibration caused by hammering in the nails can loosen weak areas of gilding and mouldings.

The following procedure applies to painting frames: after removal of the painting, the front of the frame is dusted with a pony-hair brush and the reverse and rebate with a hog-bristle brush. The frame rebate is lined with paper and felt. The gummed paper isolates the felt adhesive from the wood and the felt protects the painting edge from abrasion and acts as a barrier against dust. Balsa wood spacers are used to ensure the painting does not slip. The spacers are pinned in place using a pushpin to avoid the vibration of hammering. The painting is fixed securely into the rebate using screwed brass strips that are bent to follow the contour of the reverse.

The National Trust has carried out a research project to find appropriate methods for backing paintings (Caldwell and Harwood 1996; Caldwell 1998b). Among other criteria we wanted a transparent material so that any inscriptions on the reverse of paintings would still be visible, and conservators would be able to inspect the reverse of paintings for signs of mould growth, or other problems, without removing the backing. A thick grade of Melinex® was selected for paintings on display in the houses. Polycarbonate Twinwall®, a rigid material that withstands impact, is used for paintings that are loaned. The backing is sealed to the reverse of the frame with acid-free tape. An important advantage of Melinex® is its flexibility, allowing it to be bent around protruding stretchers and sealed to the frame without needing a build-up, which would interfere with the way that the frame hangs on the wall.

Frame conservation in studios

There are a number of reasons why a frame may need treatment in a conservator's studio. I have already mentioned structural treatments that are too time-consuming to carry out *in situ*. The other main category is treatment to improve the appearance of a frame. This may be removal of dirt that has become imbibed in the gilding, or it may involve the removal of layers of later gilding or surface treatment to reveal the original gilding. Decisions about treatment that affects the appearance of frames – that is, restoration rather than conservation –

have to take many factors into consideration. Careful thought must be given to the relationship between the frame, what it surrounds and the rest of the room. Frame conservation is very often undertaken at the same time as painting conservation, thus maintaining a similar standard of appearance between the two, but this cannot be considered in isolation from the other contents of a room. To take an extreme example, we must be prepared to recognize the difficulties of restoring paintings and frames in a room furnished with severely deteriorated textiles.

Decisions about which frames should undergo studio treatment involve many specialists. As well as consulting the conservator and the curator, we are increasingly using technical examination by scientists as a precursor to treatment. The preparation of cross-sections is particularly helpful in understanding alterations that have been made to gilded layers.

Guidelines for frame conservation

As many conservators and members of staff are involved in conservation in the National Trust we have prepared a set of guidelines that are made available in the National Trust Conservation Manual. This Manual is regularly updated. It is currently only available in paper form, but it will soon be available on the National Trust Intranet. In the future it may be available on the National Trust website. We do not intend to publish it as a book as we would then forgo the possibility of regularly updating information. Many of these guidelines are relevant to this paper [3].

Cycles of treatment

A study of historic records for paintings conservation in museums and galleries, as well as in country houses, showed that, on average, paintings undergo a major intervention, such as relining, removal of discoloured varnish or restoration, every 100 years (Staniforth 1996). Minor treatment, including surface cleaning, consolidation, and application of preventive conservation measures such as tying wedges, conservation framing and backing, is carried out every 25 years in National Trust houses. We have no comparable data to inform decisions about cycles of treatment for frame conservation. In the absence of these we have taken a pragmatic view and proposed that frames should be treated at the same time as the paintings that they surround. But what about mirrors and works of art on paper? More information is needed.

In the meantime, there is a large backlog of frame conservation, since many frames have been ignored when paintings have been conserved and are now in urgent need of treatment. Regular cycles of treatment can only start once the backlog is cleared.

Economics of frame conservation

Although it is clear that every frame should be treated as an individual object, in a collection as large as the National Trust's it should be possible to determine an average conservation cost. This has been done in great detail for paintings conservation and followed for a number of years. We know that the average cost, per painting, for *in situ* treatment was £100 and for studio work was £1,500 in 1999. As paintings need *in situ* treatment every 25 years and studio work every 100 years, this amounts to a cost of £4 and £15 respectively, totalling £19 per painting per year. This type of data is essential for conservation planning. Property Managers are asked to budget £19N for paintings conservation, where N is the number of paintings in the house. In the absence of proper information we are proposing a figure of £10 per frame per year. We are beginning to collect data on the number of frames treated during *in situ* visits and the cost of these visits, and the average cost for studio conservation, but at present not enough frames have been treated for the study to have statistical significance. Information on frame conservation costs would also be very helpful.

Conclusions

This paper is characterized by a disappointing ignorance of many of the crucial bits of information that are needed properly to manage a collection of frames. Although the National Trust can take some comfort from the fact that its high standards of preventive conservation and housekeeping will help to maintain frames in their present condition, or at least slow their rate of deterioration, the remedial conservation programme is still at a relatively early stage. It is encouraging that the curatorial and conservation surveys that were only started in 1982 are now almost complete. We know the scale of the problem. We have made some progress in beginning to tackle both *in situ* and studio treatment, but there is a long way to go. We are hampered by insufficient information when setting budgets. We can 'cherry pick' the frames that are in obvious and urgent need of attention and get estimates for their treatment, but we can only guess at reasonable budgets to maintain frames once the backlog is cleared. And without regular expenditure, backlogs will build.

I am aware that this paper may give the impression that the National Trust adopts a very mechanistic approach to frame conservation, but I am telling only one side of the story. We have endless debates about the appearance of frames and their relation to each other and the other furnishings of a room. There are many case studies that could be used to illustrate these fascinating debates, and I hope that these will be discussed in future papers.

Acknowledgements

I am grateful to my colleagues Alastair Laing and Christine Sitwell for reading and commenting on drafts of this paper. Victoria Boyer persuaded me to write the paper and has greatly assisted the National Trust in putting its house in order as far as frame conservation documentation is concerned. Without this documentation management is impossible and we thank Victoria for the part she has played. We are also grateful to Hermione Sandwith for her role in making the Trust realize the importance of frames and initiating the frame survey, and to the many conservators who have contributed to the various surveys, some of whom are mentioned in this paper.

Notes

1. 'T' and 'U' bars are made in a range of sizes and consist of softwood bars protected with Plastazote® cushioning. They are extremely versatile and can be reused.

2. The National Trust calls work that is done by conservators in houses 'in situ'. It does not necessarily imply that objects remain in their usual positions. They may be moved within a house to a convenient place for the conservator's work.

3. Guidelines in the Conservation Manual that are relevant to this paper include:
 • Frame Conservation for the National Trust
 • Frame Conservation Treatment *In Situ*
 • Frame Conservation Documentation *In Situ*
 • Frame Conservation Treatment in Studio
 • Frame Conservation Documentation Studio
 • Conservation Framing of Paintings
 • Backing Paintings in National Trust Houses
 • Handling Paintings
 • Specification for 'T' and 'U' Bars

References

Anon 1800, *Domestic Management, or, the Art of Conducting a Family; with Instructions to Servants in General. Addressed to Young Housekeepers*, London, H. D. Symmonds.

Anon 1820, *The Young Woman's Companion or Female Instructor, being a guide to all the Accomplishments which Adorn the Female character*, Halifax.

Caldwell M. and Harwood C., 1996 'The National Trust's backing project' in *The Picture Restorer*, Volume 10, 19–21.

Caldwell M., 1998a 'Anoxia treatments for pest infested paintings and frames', unpublished report, The National Trust.

Caldwell M., 1998b 'Backing Paintings', unpublished report, The National Trust.

Glasse H., 1760 *The servants directory or house-keepers companion*, London.

Rose J., 1998 'An investigation into the domestic care of paintings in English country houses in the 18th and 19th centuries' in *Studies in the History of Painting Restoration*, (eds) Sitwell C. and Staniforth S., London, Archetype Publications/The National Trust, London, 139–179.

Sandwith H., 1985 'National Trust Picture Frame Survey' in The International *Journal of Museum Management and Curatorship*, Volume 4, 173–178.

Sandwith H. and Stainton S., 1993 *The National Trust Manual of Housekeeping*, revised edition, London, Penguin/The National Trust.

Staniforth S., Hayes B. and Bullock L., 1994 'Appropriate technologies for relative humidity control for museum collections housed in historic buildings' in *Preventive Conservation: Practice, Theory and Research*, London, IIC, 123–128.

Staniforth S., 1996 'The management of paintings conservation in National Trust houses' in *The Picture Restorer*, Number 9, 19–22.

Whatman S., 1776 *The Housekeeping Book of Susanna Whatman 1776–1800*, first published in 1776, reprinted in National Trust Classics, London, Century/The National Trust, 1987.

Yoon Y. H. and Brimblecombe P., 2000a, 'Dust at Felbrigg Hall' in *Views*, Number 32, The National Trust, 31–32.

Yoon Y. H. and Brimblecombe P., 2000b, 'Contribution of dust at floor level to particle deposit within the Sainsbury Centre for Visual Arts' in *Studies in Conservation*, Volume 45, Number 2, 127–137.

Materials

Acid-free card:
Atlantis, 7–9 Plumber's Row, London E1 1EQ.
tel: 020 7377 8855

Bubblewrap®:
National Packaging Group plc, Unit 2, Quadrillion, West Mead Industrial Estate, Swindon, SN5 7UL.
tel: 01793 684002

Medite ZF® – low formaldehyde medium density fibreboard:
Willamette Europe, 10th Floor, Maitland House, Warrier Square, Southend-on-Sea, Essex, SS1 2JY.
tel: 01702 619044

Melinex 401® (with laminated anti-slippage coating on one side that has anti-static properties), 125 micron, (polyethylene terephthalate):
PSG Group Ltd, Polymex House, 49–53 Glengall Road, London, SE15 6NF.
tel: 020 7639 2075

Plastazote®:
Polyformes Ltd, Cherry Court Way, Stanbridge Road, Leighton Buzzard, Bedfordshire, LU7 8UH.
tel: 01525 852 444

Polycarbonate twinwall sheeting (6mm):
Formertons, Unit 39, City Industrial Park, Savon Road, Southampton, SO15 1HG
tel: 01703 332761

Biography

Sarah Staniforth read chemistry at St Hilda's College, Oxford. She then studied for a Diploma in the Conservation of Easel Paintings at the Courtauld Institute of Art, London University. From 1980–1985 she worked with Garry Thomson in the Scientific Department of the National Gallery. In 1985 she joined the National Trust where she stills works as Adviser on Paintings Conservation and Environmental Control. She has been a Directory Board member of ICOM-CC. She is a Vice-President of IIC and an Accredited Member of UKIC.

10 Dip and strip, not quite but almost

John Anderson

Conservation Department, Tate Britain
Tate Britain, Millbank, London, SW1P 4RG
tel: 020 7887 8073 fax: 020 7887 8059 e-mail: john.anderson@tate.org.uk

Abstract

The Tate Gallery has thousands of paintings, watercolours and drawings, dating from the late sixteenth century to the present day, and is constantly enlarging its collection. In order to keep up with newly acquired works and display demands, as well as continuing to tackle the existing collection, Frame Conservation has had to develop a variable and flexible approach to carrying out its main tasks of conserving or restoring original or contemporary frames. Over the years this department has also undertaken to make occasional reproduction frames, and to maintain and enlarge a picture frames archive that is now frequently used by staff and many researchers from outside. The determining factors for treatment include the structural condition, which is considered the most important for the protection of the artwork, the visual condition (also taking into account that of the artwork) and the time that can be made available. Many of the projects undertaken are long-term and involve severely deteriorated frames that have been stored in deleterious conditions for decades, and have lost substantial parts. The practical output to date has ranged from simple consolidation to extensive rebuilding, cleaning and regilding. The title of this paper refers to the shock felt by some people when confronted by large areas of new, lightly toned gold. However, the decision to undertake such apparently invasive work is never made lightly, and is always based on what, at the time, is considered sound practical reasoning.

Key words

Frames, conservation methods, conservation ethics, modifications for glazing, modifications to restore strength, conservation versus reproduction

Introduction

The Tate Gallery has one of the largest collections of fine art in Western Europe. It is constantly expanding, acquiring work by contemporary artists as well as filling historical gaps. At the same time, it is constantly displaying, with a formidable programme of loans, tours and special exhibitions in its four galleries. The Frame Conservation department's task is to protect and preserve the Tate's paintings, as well as prepare them for public display. Stringent modern standards have to be met, but care must also be taken not to compromise the integrity of what might be a contemporary frame – possibly even the artist's own. We have therefore had to develop a flexible approach, considering the factors of each case individually before deciding the extent and nature of the work required.

This necessary flexibility means on occasion being prepared to take radical steps with frames in a bad state of repair – removing previous attempts at restoration, for example, in order to understand what the frame looked like originally. Dip and strip, not quite, but almost. Some people are often very concerned by the 'invasive' nature of such methods, especially in the case of gilding. New gold can seem incongruous with an old picture. The extent to which gold is toned is largely dependent on the visual appearance of the painting, and toning is often an occasion for much discussion. Nevertheless, we do not, as a general rule, attempt to 'antique' new gilding, except when blending new gold into old. Rather, we attempt to reduce the newness of new gilding and 'help' the general wear-and-tear on its way, aiming for a look that is about twenty years on.

These are interventive methods that look to the long-term preservation of a picture and frame, and that attempt to undo the problems caused by previous, less considerate restoration work. Even if it is decided to replace an old frame altogether, with a new copy, the original is still stored in our Picture Frames archive, so as to be available to staff and researchers for future reference.

Glazing conversions

The need to protect pictures with glazing – which in the case of the national collections can be traced back to the middle of the nineteenth century – is one of the main causes of problems dealt with by the department. At some point towards the end of the nineteenth century it was decided to alter the structures of the Tate's frames so that heavy glazing could be removed via the front. To achieve this the frame – often a carved frame – was cut and enlarged to allow for the insertion of an additional glazing frame or door, which would then be held with slide bolts.

Alternatively, if the frame was a nineteenth-century composition frame, consisting of a heavily decorated outer frame encompassing a more simple inner frame, it was this inner or slip frame, with minor adjustments, that was usually converted for glazing. However, if a slip frame was not present the front moulding would be sawn off the main frame and used to create the glazing door. This often meant the loss of decoration, either during the removal or later when weakly glued to thin, frequently handled door sections. Eventually, if considered damaged beyond repair, the decorated door would generally be replaced with plain gilded mouldings, though even these are now invariably missing or badly damaged.

Behind the door sat a second frame or flat, where the picture was fitted. In later versions it was possible, in the event of fire or flood, to remove both the door and the flat, leaving the frame still hung on the wall. This invasive glazing system has severely weakened so many frames that almost all have to be strengthened to make them exhibitable.

Another disadvantage of this method of glazing is that the picture plane is pushed back several centimetres, so that the intended unity of picture and frame is disturbed. This can be clearly seen when the frame overshadows part of the picture surface, and is particularly noticeable with early Pre-Raphaelite framing. All these factors – strength, loss of original decoration, and the harmony of picture and frame – must be taken into account, as well as the time pressures inevitable when maintaining a collection in constant demand.

Case One: an early nineteenth-century composition frame

A typical example of a 'cut for glazing frame' dealt with by the department is the recently restored frame from Turner's *Apullia in Search of Appullus* (exhibited 1814). Thought to be one of Turner's gallery frames and certainly dating from before the Turner Bequest of 1856, it was originally only considered for emergency conservation, because the lower rail was splitting, due to failure of a glue joint in the laminate of the bottom rail. If left untreated this would have resulted in a major loss of fine composition decoration from the top edge or knull of the frame.

Examination

This frame, 1921 mm x 2851 mm, would have been altered for glazing in the first half of the twentieth century, possibly as late as the 1930s, when large sheets

Figure 1 Turner. Space left by missing glazing door. © *Tate Gallery*

of quality glass were more available and affordable. This had been achieved by taking away part of the front decoration and slip frame so that a removable glazing door could be bolted in the new opening. This door had since disappeared, leaving the painting and flat exposed (Fig 1).

Typically for a large frame of that age, the mitres (45-degree joints) were moving apart, the glue blocks on the back had partly detached and only a few cut nails were holding the corners together. The bulky, soft-wood build-up butt jointed to the back of the frame had added no real strength, only extra weight.

The surface was worn and dirty with some composition loss and extensive areas of bronze paint used to mask loss of gold. The frame had subsequently been toned down several times in order to even out the increasingly patchy surface.

In an attempt to reduce the number of times an object is treated, simple briefs are often enlarged to deal with as many of the problems as is possible. So although the priority with this frame was to secure the failing glue joint, it was decided to try and tackle the visual as well as the structural defects, and to rethink the glazing.

Treatment

After a drawing of the section had been made (Fig 2), and cleaning tests carried out, the knull composition was carefully removed, along with all the non-original woodwork.

At this point the delaminating timbers were completely separated and the old glue cleaned off. They were then refixed with hide glue and steel screws, as were two other rails that were beginning to separate. A new rebate was then cut below the small hollow at the front of the frame and a jointed redwood (*Pinus sylvestris*) build-up applied, supplanting the old glue blocks. The new build-up was a jointed wooden structure, fixed to the back of the frame to supply extra strength and wraparound protection for the artwork, and was made to a size that would accommodate a new slip frame and future glazing.

The front of the frame was initially cleaned, but little gold remained and the bronze paint could not be satisfactorily removed. After much deliberation it was decided to use a commercial paint stripper to reveal and clean the remains of the clay layers. Losses to the white layer were then made up with size-chalk putty and coats of whitening. The composition decoration was returned to the frame, secured, and minor repairs were carried out.

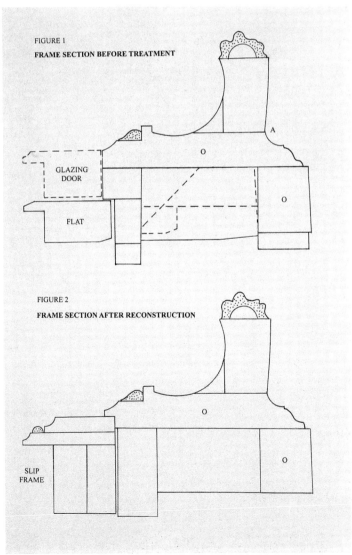

Figure 2 Turner. Diagrams showing before and after treatment. © Tate Gallery

Figure 3 Turner. Corner detail of treated frame. © Tate Gallery

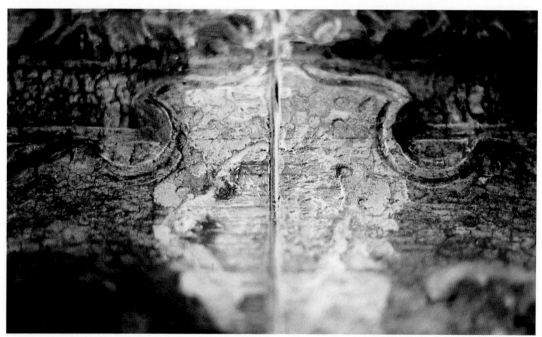

Figure 4 Lambert. Rejoined centre cartouches, with dry stripping revealing evidence of missing rosettes. © Tate Gallery

As no record could be found regarding the original look of the area around the sight edge, a new slip frame was designed and constructed (Fig 2), based on slip frames found on two contemporary Turner frames at Petworth House. The newly whitened areas were coloured with clays matched to those fragments still surviving, although artistic licence had to be used regarding the slip frame.

The main frame and slip frame were then oil and water gilded, toned and distressed (Fig 3).

Case Two: a mid eighteenth-century carved frame

A contrasting example to the work undertaken on the Turner frame is the treatment presently being carried out on a carved English Rococo frame belonging to a *Landscape* by James Lambert, dated 1769. This frame had also been altered to accept a glazing door, but this time it was achieved by cutting through each of the four central ornamented plates or cartouches (Fig 4) and enlarging with new carved material. It had then been

substantially built up at the back, but (as in the case of the Turner) with no inherent strength.

Examination

Here the structural treatment consisted of removing the non-original material, thus reducing the frame to its original size. A very simple jointed build-up was then added to the back to accommodate glazing, slips, the painting and a backboard.

The surface of the front of the frame was identified as a second layer of oil gilding laid over a thin white. Underneath was the original oil gilding, typical for this period and this type of English frame. As happens so often with this combination of surfaces, there is invariably movement between the layers. In this case it had resulted in flaking, particularly on recessed areas and around carving. The frame was also quite dark – the effect of dirt, later toning and small areas of bronze paint, particularly around areas of broken carving.

Treatment

It was decided to keep the second gilding, as it was in reasonable condition, despite the flaking. The treatment decided on consisted of cleaning with a 4 per cent solution of tri-ammonium citrate and de-ionized water. The flaking was then consolidated with rabbit-skin glue and heated spatulas. This has allowed further cleaning in some areas without the increased risk of losing original material.

The rest of the work, yet to be completed, is to remove the bronze paint, replace the broken carving, gild and tone. This job is an example of the more straightforward problems the department deals with, and is common in the case of carved frames, as they tend to have survived mostly intact, though frequently regilded. In contrast, composition frames, because of the heavy and brittle nature of the material, rarely wear well or remain complete. The continuous loss of decoration invites temporary solutions painted over with the ubiquitous 'gold' paint, usually a mixture of shellac and bronze powders.

Replicas

Some of the more radical solutions developed by the department bypass ethical concerns about the extent to which gilded surfaces should be conserved/restored, as the next two case studies illustrate. Here consideration of the problems presented has resulted in replacing 'original' frames.

Case Three: an early twentieth-century cast frame

The painting *Bouquet of Flowers*, *c.* 1909–10, painted by Henri ('Le Douanier') Rousseau, was bequeathed, framed, to the nation in 1933. One morning in May 1998, while on a picture screen in store, this frame was

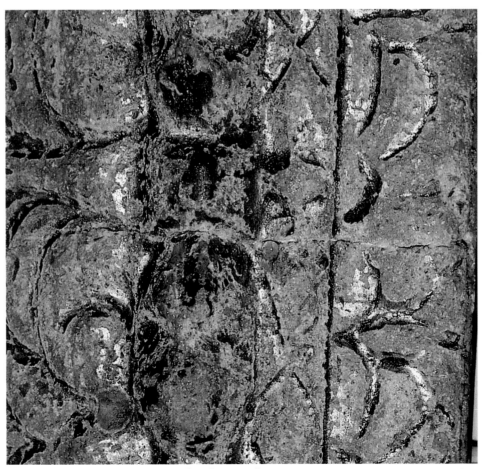

Figure 5 Rousseau. Saline droplets on surface. © Tate Gallery

discovered to be dripping copious amounts of brown liquid over the painting below, which, fortunately, was protected in a transit frame (Fig 5). The scene was immediately recorded and the picture, luckily unaffected, was unfitted. An investigation was then initiated, and although it is not yet complete, we now have a general idea of the cause.

Examination

Samples were taken from the frame for analysis. The frame was then bagged up and allowed to equilibrate with the accepted museum conditions of about 55 per cent relative humidity, whereupon white salts could be clearly seen deposited on the surface.

The casting material used to make up the frame consisted of, among other things, long coloured fibres, wood dust, hide glue, chalk and magnesium silicate (although the latter may be a by-product). What we do know is that this composite material had absorbed large amounts of moisture from the air and when the ambient temperature, relative to humidity, dropped below a certain level, the moisture precipitated. The investigation also revealed that the monitoring of the conditions in the store had been inaccurate and there had been several unnoticed and rapid changes in relative humidity only a few days before, which would have allowed plenty of time for the deliquescence to begin.

The surface of the frame is heavily pitted and there are only traces of gold left, with what looks like a green

glaze. It is even possible that the casting predates the painting and was adapted to form a frame. Questions remain. Is the pitting and loss of gilding due to earlier deliquescent episodes, or is it a deliberately 'decayed' finish, analogous to the heavily distressed surfaces of some Impressionist frames? If the latter hypothesis is the case, could the subsequent deliquescence be the result of the materials used to achieve the required effect? We may never know, as an early record of its surface appearance may not exist.

As the future reaction of this frame could not be guaranteed in a changing environment, it was decided to make a replica in tried and tested materials.

Treatment

We began by brushing away the salts, then consolidating the surface of the now dry frame with rabbit-skin glue, and restoring the worst losses with size and chalk. As the frame was not very large (850 mm x 727 mm), it was then possible to take a one-piece silicone rubber mould, with a plaster jacket, from it.

A plaster cast, with size added, pigmented to match the original and backed with plasterer's scrim, was cast from the mould and attached to a jointed redwood subframe. Finally the gold and paint effects were copied and toned.

The original frame is now in store, fitted into a purpose-made sealed box, which buffers the frame against fluctuations in relative humidity. This box has a Perspex® front, which allows for periodic inspection.

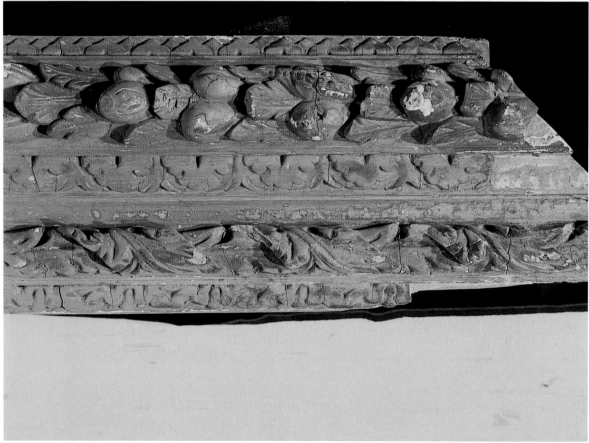

Figure 6 Sargent. Original frame section. © *Tate Gallery*

Case Four: a late nineteenth-century composition frame

Carnation, Lily, Lily, Rose was painted by John Singer Sargent in 1885-6 and was presented, framed, to the nation in 1922. It was required for display by the 1998 Sargent exhibition, but even though it is one of the most popular paintings in the collection, there was no record of it having been displayed in its original frame, or even in a complete frame. As a result, no one knew what the original frame looked like or even if it still existed. Luckily, a researcher found an old installation photograph. It is of the Royal Academy Winter Exhibition, dated 1926, and clearly shows *Carnation* in an early frame, the overall design of which matches those found on other Sargent paintings of the same period.

In 1987 one of the Tate's storage facilities was being closed down and, in the process of transferring the stored items, the frames among them were all inspected and photographed. Checking the photographs revealed the *Carnation* frame was among them (Fig 6).

Examination

Only three of the rails could be found and these were badly delaminating, with the whitening substantially perished. This frame, like so many, had been weakened by being cut and enlarged for glazing. Then for years it had been stored in damp and dirty conditions. The heavy composition elements, although mostly complete, had deeply cracked and the overall surface was dirty, pitted and scratched. The 1926 photograph made it possible to ascertain that it was the bottom rail that was missing. Had it disintegrated and finally been thrown away?

It was concluded that even though a new bottom rail could be made easily enough, the other three rails would have to be taken apart and rebuilt. An attempt would also have to be made to consolidate all the whitening or it would have to be replaced. Either measure would involve temporary removal of the composition in order to gain a measure of stability. Although taking this route could have prolonged the work significantly, time was not the prime consideration. Rather, it was decided that such a process would be radically invasive, breaking up and causing the loss of a lot of original material.

The other option considered and finally undertaken was the making of a replica. This solution produced a stronger, safer frame to be made for the painting and allowed the original frame to be stored unaltered in the Archives.

Treatment

This large new frame, 1950 mm x 1737 mm, is made from whitened redwood and closely follows the original section. It has a build-up that provides a fully jointed support and is designed for strength, ease of transport, glazing, slips, painting and backboard.

The decoration differs in the use of material. After polyurethane rubber moulds were taken from partially cleaned and temporarily restored areas, a hard casting plaster was used to replicate the lines of composition.

The reasoning behind this was that it would capture all the details of the old composition and avoid the loss of detail and additional shrinkage to the design that would occur if new composition were used. It has become almost standard practice in the studio to consider using plaster in order to avoid the slumping effect of drying composition. The plaster casts were fixed to the frame with hide glue and losses were made up with plaster or size and chalk putty.

The oil gilding (which made up the majority of the gilding), and the water gilding, with its use of red bole and 'blue burnish', were closely copied, although artistic licence was used on the corner straps, as so little of the originals remained. The new gold was toned down in several stages, the last of which was in the gallery while the exhibition was being hung.

Conclusion

The constant pressure for paintings in the Tate collection to be moved and exhibited make it imperative that the frames are maintained at high standards. They have to protect as well as display, and at the same time are often important objects in their own right. It is sometimes difficult to square this circle. The conservator has to construct treatment proposals for particular aspects of a frame, taking time and resource limitations into account. That is not to say considerations about the ethics of 'invasiveness' are last on the list, but rather that they have to be as flexible as the department's approaches are variable. One fixed standard of 'non-intervention', for example, is not always in the interests of the picture or the viewing public. The deduction of the historical relationship between painting and frame can, therefore, be crucial in the decision-making process.

Acknowledgements

Thanks in particular to Steve Huxley, Cliff Deighton, Petra Olyslager and Charlotte Alexander who actually carried out the work. Additional thanks to Dr Joyce Townsend who helped greatly on the analysis, to the Conservation Technicians and to all the other members of Tate staff who gave advice and support.

Materials

(Hazard data sheets should be obtained from the suppliers and COSHH assessments carried out before use).
Tri-ammonium citrate:
BDH – Merck Ltd, Hunter Boulevard, Magna Park, Lutterworth, Leicestershire LE17 4XN.
freephone 0800 223344 fax: 01455 558586
htttp://www.merck-ltd.co.uk
Moldsil RTV silicone rubber:
Poylurethane 74 Series liquid rubbers:
W. P. Notcutt Ltd, 25 Church Road, Teddington, Middlesex TW11 8PF.
tel: 0208 977 2252 fax: 0208 977 6423

Perspex (Plexiglas):
Amari Plastics plc, 2 Cumberland Avenue, Park Royal,
London NW10 7RL. tel: 0208 961 1961
Casting plasters:
Alec Tiranti Ltd, 70 High Street, Theale, Reading
RG7 5AR. tel: 0118 930 2775, or 27 Warren Street,
London W1P 5DG. tel: 0207 636 8565

Biography

John Anderson gained a Diploma in Art and Design
(Fine Art and Sculpture) at Maidstone College of Art.
He joined the Conservation Department at the Tate
Gallery as Museum Technician in 1973. Since taking a
short course in Gilding and Restoration in 1980 with
Malcolm Green at the Victoria and Albert Museum, he
has concentrated on picture frames. He established the
Picture Frames Conservation Department in 1985.

Working with gilded furniture for the British galleries at the V&A

Christine Powell

Senior Conservator of Gilded Furniture

Conservation Department, Victoria and Albert Museum, South Kensington, London, SW7 2RL

tel: 0207 942 2098 fax: 020 7942 2092 e-mail: c.powell@vam.ac.uk

Abstract

The V&A is currently preparing for the opening of the new British Galleries 1500–1900. The project is one of the largest the V&A has ever undertaken. Thousands of objects have been removed for conservation work prior to the refurbishment of the fifteen galleries that form the new display. The Furniture Conservation Section has been responsible for advising on the packing, handling and treatment of over fifty gilded objects, including gilded wood, composition, leather, metal, and silvered wood.

The objects have required different levels of treatment prior to display, depending on their condition, the extent of any damage or loss, and the soundness and appearance of any previous interventions and additions. The conservation decision-making and planning process has been affected by a number of factors. Discussions have taken place between conservators and curators to investigate the known history, construction materials and finish of the objects, as well as jointly to consider the conservation and curatorial priorities, wishes and proposals for treatment. The deadlines for treatments have been set in order to meet photography needs for promotional publications, to enable other conservation departments to start work, and to meet the reinstallation priorities – for example, wall-mounted objects will need to be fitted first.

Conservation work has been undertaken by permanent V&A staff, contract conservators, students and interns. The treatments have ranged from light surface cleaning and minor consolidation to structural intervention, the removal of later finishes, repairs, and the replacement of losses. Some objects have presented unfamiliar materials and methods of manufacture, and have required research into materials before treatment. Work has followed treatment proposal outlines drawn up by V&A conservation staff for each object, and agreed with the relevant curatorial staff, and all treatments have been carried out with reference to the V&A ethics checklist. The British Galleries are due to re-open in November 2001.

Key words

Water gilding, oil gilding, overgilding, British Galleries, furniture, bronze paint, Victoria and Albert Museum

The new British Galleries: preparation

In the initial stages of the new British Galleries project a list of objects likely to be displayed was gradually drawn up and refined by the British Galleries project team and specialist curatorial staff. Preparation for selection had been going on for several years, with possible objects having their collection files checked and preliminary research carried out. Then conservation and collections staff viewed the objects together to discuss condition, materials and techniques, past treatments and later additions, and possible treatment.

There was no special brief for treatment of objects for the British Galleries. The approach was that usually adopted for work in the conservation department. The V&A ethics checklist forms a framework for the

decision-making process. In the British Galleries display, the objects are generally seen in their period context, though occasionally they are there to illustrate an earlier source of influence on later style and techniques. In most cases the maker's and designer's intention for the piece is an important consideration. The V&A is a museum of the decorative arts, and it is one of our aims that the objects on display may be better technically understood and appreciated.

Selection

The objects were selected on a variety of criteria. First, they had to fulfil an educational and illustrative role – an object might represent a style or taste of a period, or illustrate an innovative function, or utilize special materials or techniques. An object that retained its original gilding, was, of course, a bonus, but in reality it is not unusual to find that gilded objects have been overgilded at some point in their history. Sometimes materials and techniques different to those used on the earlier finish are present. Other accretions, such as wax and dirt, can make the gilded object look very different from what was originally intended. The complex conservation issues raised by the prevalence of over gilding is one of the issues we hope the new British Galleries project will enable people to appreciate.

Previous treatment

Working files were opened for all British Gallery objects. The objects had varied histories of treatment. Existing documentation of conservation treatment was consulted. Many objects, however, had no such documentation and in many cases evidence about past treatment was discovered by examination of the objects themselves. Many were found to have been overgilded or painted, sometimes more than once. In some cases the overgilding was found to follow closely the earlier scheme, both in terms of materials and technique. This could well indicate a relatively early overgild, possibly carried out within fifty years of manufacture of the piece. However, there were clues that indicated that it might also be more recent work.

In some cases of recent water gilding the gold leaf is found to be artificially worn in order to show the bole. This may be carried out evenly over the whole piece, without attempting to imitate realistic wear. It may then be followed by subtle toning and a light application of dust. This type of finish may not be a total overgild: it may include the remains of an original finish, with only the losses in-filled and gilded. Often, new gold leaf is applied over both the new in-fills and the earlier surface in order to 'lift' the gilded appearance. In other cases it may be found that this is a totally new finish, intended to replicate old work. Close scrutiny and familiarity with restoration and reproduction techniques is required to help identify each case.

Sometimes, the gold leaf may be carelessly laid on, with spotting (where the gold has not made good contact) occurring too evenly over the piece. The thinking behind this technique is that, after artificial abrasion and heavy toning, it will create a general effect of age to the untrained eye. This type of finish is believed to have been carried out this century.

The overgilding may employ different materials or techniques: a different colour used for the gold, for example, or a preparation of clay bole applied over an earlier water gilded finish. Oil gilding may be used where previously there was water gilding. A change of this kind is often due to the later scheme being more fashionable at the time of execution.

The thickness built up by the subsequent layers of overgilding can obscure earlier relief details of the sculptural modelling. For example, details that had been cut into the white ground may be softened or lost under the later gilding layers. The ground used for an overgilded finish may have been recut in a different way to the earlier finish.

Time limitations

Generally, where sound overgilding was found closely to replicate the earlier gilding scheme, it was agreed that this finish would be left and conserved. Even if the present finish was found to be different from 'the maker's original intentions', this did not necessarily mean that it would be removed or altered, especially if it was sound. Some objects were considered acceptable with their later finish. In other cases, although the overgilding might be deemed a poor repair, complete removal was not contemplated – ethical issues aside, the simple fact of the amount of time available often made this decision for us [1]. This is not to say that it will not be considered in the future.

It was also not possible, given time limitations, to carry out cross-section analysis in every case. We cannot therefore prove that the earliest finish (the first finish found applied over the wood) is the original. We had to trust to experience to tell us whether a finish is correct for a period (and therefore likely to be the original), or whether it is a complete regild following the decoration of the original, or a repair gild including earlier work (both possibly relatively early themselves). Evidence of earlier schemes was documented, and information of the gilding schemes found on the objects will hopefully be made available to the museum visitor.

Decision making

The usual process for treatment decisions was followed. First, the Conservation Section would examine the condition and technical history of the object. Then, the curators would provide information on the provenance and art and design history, and together they would discuss the treatment proposal options in order to decide on a treatment within the limits of the project. It was generally agreed by the conservators and the curators that the gilded object should at least be given the opportunity to appear golden again. Each object was an individual case and treated accordingly. Some were chosen as 'star' objects, which sometimes allowed them extra time for treatment, but all the objects selected

were dusted and consolidated, after which essential structural work was carried out.

Many pieces could be cleaned, but after cleaning the brightness of the gilding naturally varied, due to the subtle differences of historical style and technical execution, wear of gold leaf or deteriorated materials. In a few cases the judicious application of new gold was undertaken.

Poor repairs

Some recessed areas – the result of loss – had not been in-filled with new ground, and gold leaf had either been applied straight onto glue size, bole, oil size or other mordant over the hollow loss, or straight onto the wood or the remains of the ground, something that often actually highlights damage. The gold was usually removed from these areas or coloured out.

Bronze paint

Paint made with non-gold metal powders, commonly known as 'bronze paint', had often been used to touch out losses, and was sometimes also applied over adjacent intact areas. The different texture and degree of reflection of bronze paint, compared to gold leaf, can change the appearance of the gilded object greatly. This becomes more noticeable as it darkens with age.

Bronze paint is almost always removed from water gilding, as the damage caused by doing so is usually acceptably slight, when weighed against the improved appearance of the water gilding.

In the case of bronze paint on oil gilding, removal is rarely possible without extensive loss and is undertaken only on the rare occasions when it seems possible to avoid all but minimal damage, or on the understanding that there will be some loss of the oil gilding where the bronze paint has overlapped good work. In such cases treatment is a question of damage limitation with the loss weighed against the overall improvement of appearance gained by the removal of the bronze paint, possibly followed by compensation treatment of lost gold with new, or a substitute material. It is important to bear in mind that bronze paint is often applied where gold has already been lost.

Filling and colouring out losses

Loss of a gilded finish (including the white ground) was dealt with in various ways. Visually, in-fills can pull an object together, so that its design may be read more easily and be better understood. Surface in-fills arguably add greater stability to the finish, as the in-fills protect the edges of loss from further damage. However, the edges of these losses could also be protected by consolidation without in-filling. Time permitting, larger losses were usually in-filled and gilded or coloured out, and the surrounding earlier gilding protected with a reversible isolation coating. Very small losses (that is, under 2 mm) were often accepted without filling.

Losses showing bright white ground catch the eye, in a way that is not generally considered aesthetically pleasing. If these losses are not to be in-filled, they are often coloured out, or darkened, so that they do not distract from the overall 'read' of an object. Raw umber pigment in medium is frequently used: this harmonizes well and, because it is not usually the colour of the gilding preparation (that is, red bole and yellow oil size), does not confuse the educated viewer who may be examining the object, and trying to identify the gilding and preparation layers. Wear through the gold leaf showing red bole or yellow oil size is often considered more acceptable, unless the colour of the bole dominates over the gold, and then an application of more gold, or a gold substitute, will be considered.

Heavy loss of gold leaf on the higher parts of an gilded object may well be consistent with wear through dusting and handling, but this can eventually affect the balance of the piece as it is intended to be read. For example, areas of burnished water gilding are intended to reflect light, although they will show light or dark as the viewer changes their viewing angle or the angle of the light source changes. With the heavy loss of gold, these areas can look permanently dark.

When time permits, larger losses, such as carved wood ornament, may be replaced, if there is an existing ornament that can serve as a model for new parts. The more distracting the loss the more likely it is that it will be replaced. Where poorly modelled in-fills/replacements for ornament have been carried out in the past (often overlapping good surfaces) these may either be improved, or removed and replaced.

Photography

As well as general deadlines – for the installation of objects into rooms in preparation for the opening – there were also a whole series of local deadlines, from photography for publicity requirements to the availability of loading equipment. For photography, where time permitted, the full treatment proposal would be completed; when this was not always possible, objects would be cleaned where appropriate and have any bright damage, such as white losses, coloured out.

The gilded finish can look exceptionally good in photographs, despite damage. The disadvantage of this is that from a photograph it can be hard to appreciate the work actually required on an object to improve its real appearance and – more importantly – to make it essentially sound, out of studio lighting conditions. [2]

Case studies

V&A Object No: W.44:1–1927 carved and gilded mirror with barometer and thermometer, made in London c. 1720. Pine wood with original oil gilding preserved.

This mirror retains what is believed to be its original oil gilding with pale gold over yellow oil size on a thin white ground. The surface in general suffers from fine cracks and minute cupping, but is not extensively flaking or loose. In some areas cupping was more pronounced. There were some carved wood losses, but symmetrically opposite parts remained that could have provided models for replacement parts. There were holes in the cresting

Figure 1 Mirror with baromater and thermometer. Detail of cresting during treatment, showing fills. © V&A Furniture Conservation

Figure 2 Mirror with Prince of Wales feathers. After treatment.
© V&A Furniture Conservation

and base created by countersunk screw holes. Many of the carved mirror division strips/slips applied over the mirror joins had replacement composition ornament. These had less definition than the carved wood, but were not too obvious and in this case were left, but could be replaced in the future. There were some areas of bronze paint retouching. The surface was covered with dark dust.

The piece was dusted and cleaned with stoddards solvent. Bronze paint was removed with acetone. Consolidation was carried out with rabbit skin glue size. The piece had a photography deadline, and this left little time to carry out the full treatment proposal, which was to include replacements of carving loss. A detail shot was requested of the top shell ornament where there was a small wood loss and two countersunk screw holes. A fill material was made with rabbit skin glue, whiting and glass micro balloons (50/50). This was applied with a spatula over a previously glue-sized area. The glue size was applied thickly to act as a separation layer in the event that future removal of the fill is required. This fill set quickly and was easy to smooth and tool (Fig 1). It was then coloured out with watercolour and gold powder. It forms a soft fill that will compress under pressure and can be easily removed if necessary. This was also used to fill other small losses on the piece.

V&A object No: W.86-1911, carved and gilded mirror with the Prince of Wales' feathers, 1735-1740, probably carved by John Boson, active 1720–43, to the designs of William Kent. Overgilding similar to original gilding appearance (Fig 2).

This seems to be an example of later overgilding repeating an earlier scheme. The present finish on the mirror has burnished water gilding on a red bole over a white ground. Beneath this present finish evidence was found

of an earlier, probably almost identical scheme (Fig 3). Although we cannot prove at this stage that this was the original gilded finish, we know at least that the object had been finished twice here with similar gilding. The later gilding had been given a heavy pigmented toning all over, very probably because the gilding was thought to look too bright and new. This toning deadened the burnished areas. Burnishing was originally done to obtain a reflective surface. It was suspected, on stylistic grounds, that the bottom central decoration was a later addition. Once the frame was removed from display the back could be examined to find further evidence for this hypothesis. There were joins in the wood, and it was also noticeably cleaner. If this is an addition, as seems likely, it is possible that the present gilding was applied over this new part and over the rest of the frame. It was decided to remove the heavy toning, consolidate any flaking and make good small losses. Then a new size toning was applied into the recesses and areas that were matt water gilded, a treatment we know to be traditional.

V&A object No: W.23-1949. Chinoiserie carved and gilded mirror, probably made in London, 1758-1760, similar to designs by Thomas Johnson (1714–80) published in 1758. Over gilding unlike original gilding (Fig 4).

This mirror had been overgilded. The early/original gilding was water gilding, probably burnished in many areas, on a red bole and medium thick white ground. Extra sculptural details would have been cut into the white ground. The overgilding is a combination of water and oil gilding on a thin white ground, with the water gilding on a dark blue red bole with a black bole for the high points, probably with graphite added to produce a deeply reflective burnish. The oil gilding is on yellow, probably linseed oil, mordant with yellow ochre. The surface was covered in a dark dust. The later gilding, which was found to be soundly attached to the earlier, was not removed. Instead, the gilded surface was cleaned, which brightened the gilding and enlivened the eye-catching, burnished highlights. The oil gilded areas lay, to some extent, where the matt water gilded areas would have been. The cleaned frame gives the general impression of a twinkling, richly water gilded object, which was felt to be a fair indication of the maker's intention (Fig 4 and 5).

Figure 3 Detail before treatment showing evidence of earlier gilding by screw damage. © V&A Furniture Conservation

Figure 4 Chinoiserie mirror. After treatment.
© V&A Picture Library

Figure 5 Detail, showing carved building with interior gilding. After treatment.
© *V&A Furniture Conservation*

***V&A Object No: P.11.1.1936. Frame carved and gilded
wood with inset verre églomisé (reverse painted and
gilded glass), for reverse painting on glass, the emperor
Chia Ching (1796–1820), giving an audience in winter.
Painting made in Canton, China. Overpainting and
gilding unlike earlier finish.***

The later finish was a very dull dark brown (possibly
pigmented paint with bronze paint), with water gilded
flats, on a water-soluble white ground. The later finish
was unsoundly attached to the earlier finish in many
places and was flaking away, giving glimpses below of
the original, mainly burnished water gilding on dark
brown red bole, over a yellow glue size coat, on a white
ground. This appeared to be in good condition.

It was discovered that the leaves with crosshatching
in between were cut into the white ground rather than

being carved in the wood. The hatching detail was lost
under the later finish.

As good condition burnish gilding often allows for
the mechanical separation of later finishes, investigative
treatment tests were carried out. It was found that the later
gilding could be successfully detached from the earlier
finish by flicking it off with small metal spatulas or plastic
tools. Treatment has begun to remove the later finish.
Losses of the original finish will be in-filled (Fig 6).

Conclusion

The new British Galleries project has raised many ques-
tions about the conservation and presentation of gilded
furniture, and how this is perceived and understood by
the specialist and non-specialist viewer at the V&A. We

Figure 6 Frame for reverse painting on glass. Detail of over painting and gilding partly removed (centre) to reveal burnished water gilded finish with cutting in the white. © V&A Furniture Conservation

hope the new displays will go some way towards increasing public understanding of these questions when the Galleries open in late 2001. Importantly, it has given conservators and curators the opportunity to investigate the past history of many objects in the collection, and to ensure that proper documentation of conservation work is available for each object in the future. Documentation aids the identification of past treatments and future work. Its preservation is therefore very important. When deciding treatment we must also consider the implications for future conservators if documentation is lost or inaccessible.

As all repair work, such as in-fills, is non-original, it is generally expected where possible that all should be reversible – this is a factor we have been constantly aware of during this project. However, we certainly cannot assume that conservation will be any better funded in the future, and we should not rely on a situation where treatment may constantly be updated. Intervention, though reversible, must consider a treatment's longevity, and be executed to the highest standards possible in the circumstances.

The first priority is the object's long-term soundness. Once this has been ensured, we can discuss leaving what cannot be done now – whether through lack of materials, resources, solutions, skill, or knowledge – for the future. With this in mind, materials long known to be reliable are used whenever possible. It is important that time for learning about, and experimenting with, new or less familiar methods and materials is made available to

the conservator, both for their professional development and the health of the objects they are working with. Time for such activities should not be seen as a luxury, but as part of a conservator's ethical responsibility.

Acknowledgements

Zoe Allen and Fiona Mallinson, contract gilding conservators at the V&A, and Stephanie Adolf and Genoveva Cuesta Romero, Furniture Conservation interns at the V&A.

Notes

1. If, after going down the complex road of ethical issues, it is decided to consider removal of overgilding, the following must also be borne in mind. Earlier gilding covered by overgilding may have well been exposed to less wear than the overgilding, and in fact have been protected by it. However, this is not always the case. Before going ahead with removal of a later finish, investigation must establish the condition of the earlier finish, and how successful removal would be. Removal of overgilding is usually a very time-consuming process, unless oil gilding or other non-water-soluble gilding has been applied without glue-sized preparations over water gilding. Time trials of actual scrape tests may need to be carried out. After the removal of the overgilding/painting extensive work may be needed to fill in losses.

2. Photography raises the issue of the important role gallery lighting plays in the presentation of gilded objects. Lighting can drastically change the presentation of the object, highlighting or softening relief details and affecting the perceived colour of the gilding. Does one imitate, perhaps on special occasions, the period lighting?

Materials

Glass micro balloons:
OMYA, Curtis Road, Dorking, Surrey RH4 1XA. tel: 01306 747431 or 747555

Mica powder:

Artist's watercolour (raw umber):
L. Cornelissen and Son Ltd, 105 Great Russell Street, London WC1B 3RY. tel: 0207 636 1045 fax: 0207 636 3655

Paraloid B72:
Conservation Resources (UK) Ltd, Units 1, 2 and 4 Pony Road, Horspath Industrial Estate, Cowley, Oxford OX4 2RP tel: 01865 747755

Stoddards solvent:
(Hazard data sheets should be obtained from the suppliers and COSHH assessments carried out before use). R. and L. Slaughter Ltd, Units 11 and 12, Upminster Trading Estate, Warley Street, Upminster, Essex RM14 3PJ. tel: 01708 227140 fax: 01708 22828

Biography

Christine Powell studied at the London College of Furniture (now the Guildhall University). She spent two years at the Wallace Collection working on European carved and composition frames. She then worked for seven years as Frame Conservator at the National Gallery, London. She has been Senior Furniture Conservator at the Victoria and Albert Museum since 1993. Part of her time there is spent teaching and supervising interns at the V&A and RCA/V&A MA students. Her particular areas of interest and study are the history and techniques of gilding.

Conserving the Chiswick side tables:
A challenge for English Heritage

Dave Gribbin

Conservator, English Heritage
English Heritage, 23 Savile Row, London W1S 2ET
tel: 020 7935 3480 fax: 020 7935 6411 e-mail: dave.gribbin@english-heritage.org.uk

Abstract

This paper examines the conservation project following the acquisition of these important original pieces of furniture and their return to Chiswick House. The challenge mentioned in the title is significant in several respects. The decision to conserve the tables emerged from a prolonged evaluation of all options, including that of non-intervention. The project team used a cost/benefit analysis procedure to establish a consensus of opinion that the care of the tables – along with other priorities such as academic research and educational opportunities – should be balanced against the very substantial financial outlay of the acquisition. The specialist resources of English Heritage provided sound technical support in recording and analyzing the condition. Polarizing and scanning electron microscopy were used to examine samples of the surface coating to establish the number of layers present and their chemical composition. Further investigations utilized X-radiography and dendro-chronology to give more structural information. All of this information enabled our contract conservators, the Tankerdale Workshop, to make decisions about their approach to conserving the tables. The decision taken pursued the principal aim of revealing the eighteenth-century gilding. It must be emphasized that the excellent working relationship between the conservators and the English Heritage team proved to be very valuable in maintaining quality standards during the project. Finally, in the continuing effort to conserve the interior of Chiswick House, curators and conservators now have two important pieces of gilded furniture that give an invaluable insight into the craftsmanship and techniques of those who built the house and its furniture. The greatest challenge in the future will be to apply the methods of this project to the extensive work still to be undertaken in this unique building

Key words

Chiswick tables, Third Earl of Burlington, eighteenth-century gilding, dry stripping

Introduction

Chiswick House was probably built between 1727 and 1729 and was the creation of the owner, Richard Boyle, Third Earl of Burlington. The classical features of the house evolved from Burlington's antiquarian scholarship and extensive knowledge of Italian architecture gained on two Grand Tours, with the work of the architect Andrea Palladio exerting the strongest influence.

On such a journey to Genoa in 1719, Burlington is thought to have acquired the richly inlaid marble slabs, which, united with the gilded frames, created the superb furniture that we see today (Fig 1). The mosaic tabletops feature Egyptian porphyry and other rare specimens of marble, displayed in elaborate patterns within a Siena border. A detailed examination of the slabs and description of the many marble types is available as a report produced for English Heritage (EH) by Dr David Williams of Southampton University, and is worthy of separate consideration [1] (Williams 1997).

Interior design at Chiswick was used to express the wealth and taste of its owner. Opulent materials such as the extensive gilding throughout the house were used to emphasize the importance of the classical forms and the harmony of the entire decorative scheme.

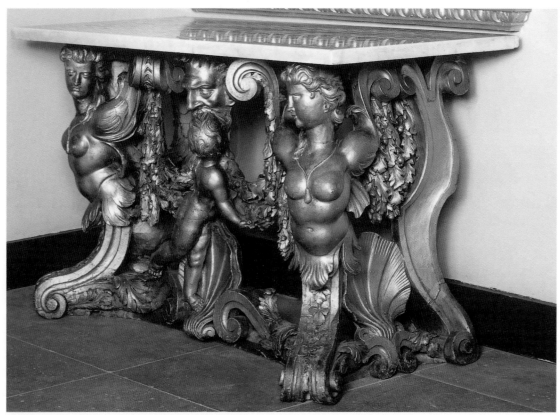

Figure 1 View of left-hand table in situ at Chiswick before conservation, October 1996. © English Heritage Photographic Library

Placing the tables in this context emphasizes their importance to Chiswick and the function of the Gallery in which they stand, which is not principally a picture gallery, but a loggia or recreational area overlooking the garden. It is thought that the tables were used to serve refreshments and to display Burlington's lavish collection of silver – which may be imagined reflected in the mirrors above.

Firmly documented in the 1770 house inventory, the earliest illustration of the tables dates to an 1822 watercolour by William Hunt that is now at Chatsworth (Fig 2). They were removed from the house in 1892 to Mount Stuart, home of the Marquis of Bute, the last private resident of Chiswick House.

English Heritage bought the tables in July 1996 with generous help from the Heritage Lottery Fund (HLF), the National Art Collections Fund, London Historic House Museums Trust and the Friends of Chiswick House.

The table maker

The precise identity of the maker is uncertain, although there are references in contemporary documents of the period to individual craftsmen engaged on the construction of Chiswick. Prominent among them were John Boson, specialist carver to Frederick, Prince of Wales, and the Italian sculptor Giovanni Battista Guelfi, possibly a recruit from Burlington's Grand Tour. Guelfi was responsible for the statues of Venus and Mercury originally set into the niches of the Gallery and the tables certainly have a similar sculpted character. The strong Baroque form of the tables might reinforce the Italian's claim, although it is

possible that the two men collaborated on their construction. It is interesting to compare the contemporary table at Houghton Hall, a Kent design for Sir Robert Walpole, which displays similar motifs but has more orthodox joinery in its structure. The carving on this table seems to be applied to a strong basic framework in contrast to the organic nature of the Chiswick examples, which emerge from large pieces of laminated timber.

The conservation project

After the acquisition a project team was established to assess the conservation requirements of the tables. This was made up of EH curators and conservators. Their first task was to decide if any work was actually necessary. The marble tops were found to be in good condition and would require little more than surface cleaning. Unfortunately, the same could not be said of the table frames.

A condition report already existed, having been undertaken by the Tankerdale Workshop at the time of the sale [2] (Tankerdale 1996). This report included analysis carried out by a specialist at University College London (UCL) of mounted cross-sections taken from the surface coating of the table frames. The microscopy had suggested a structure of gilded layers separated by numerous other layers of paint and varnish. A detailed inspection revealed many structural faults and potential problems. In summary, the left table (according to their original position in the house) was in worse condition than the right, but the following observations applied to both.

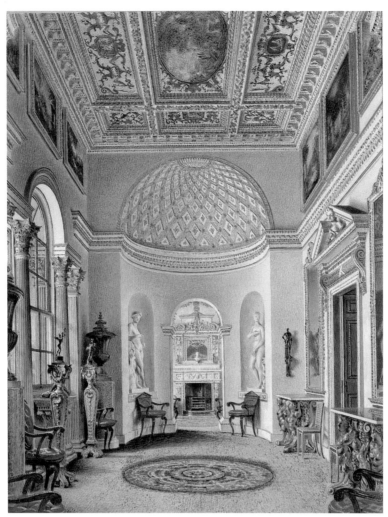

Figure 2 View of the Gallery, Chiswick House in 1822 from a watercolour by William Hunt. © Devonshire Collection, Chatsworth. By permission of the Duke of Devonshire and the Chatsworth Settlement Trustees

There were numerous cracks in the wood and losses of carving. Many of the splits conformed to the joints between the wooden blocks, which had been laminated together to form the basic shape of the frames (Fig 3). Further damage had resulted from differential shrinkage

Figure 3 Close-up of a female head, showing joint lines of the laminated block construction. © English Heritage Photographic Library

across the wood grain. The faults were probably the result of deterioration in the adhesive, environmental fluctuations and stresses caused by the heavy weight of the marble slabs. Substantial wear had exposed wood at the foot of the frame and all the dovetailed keys across the corners of the bottom rails had been lost. Many attempts at repairing the damage had been made with varying degrees of success. Extensive filling with a type of composition putty and the use of metal straps and fixings appeared to be the principal forms of auxiliary strengthening, but there was also evidence of cracks repaired with wooden fillets and lost carved detail replaced by crudely moulded composition.

The gilded surface had been generally abraded and had a dull and dirty appearance with a green tone that could be attributed to the final varnish coating.

With the table frames in this condition, the project team decided to carry out further investigations into the feasibility of conserving their structure and surface decoration. The UCL analysis had suggested the presence of four layers of gilding separated by intervening layers of paint, varnish and dirt. It was after considering these findings that the hope of uncovering what was thought to be the first layer of eighteenth-century gilding became an exciting possibility. To help further evaluate this option, a

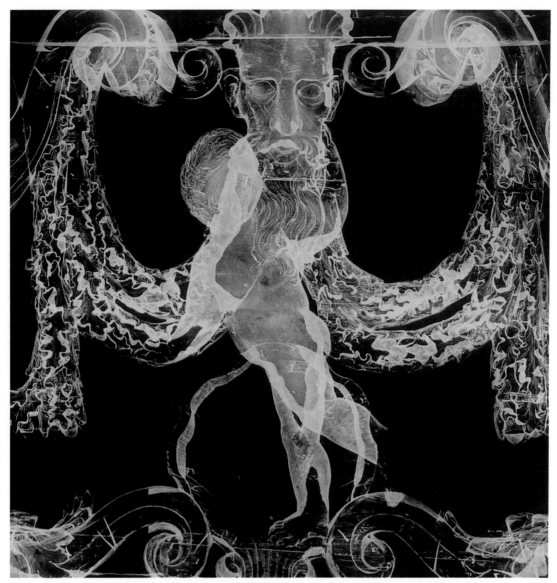

Figure 4 X-ray image of left-hand table revealing hidden fixings. © *English Heritage Photographic Library*

Figure 5 Cross-section of surface layers before conservation. © *English Heritage*

report was commissioned from Charteris Restoration and Conservation (Charteris 1996). Their specialist, Leslie Charteris, correctly pointed out the practical and ethical difficulties of separating the layers without more extensive technical evidence to support this approach. To satisfy this demand, the team was able to call upon a wide range of in-house expertise. Conventional photographic documentation was supplemented by photogrammetric recording; this gave a very accurate, measured record of the tables and the apparent damage. Dendrochronology was used to examine each wooden component and, although none of the timbers contained sufficient rings for dating purposes, measurements were taken to establish a record. The wood species was determined to be Pinus.

Each frame was X-rayed and the results confirmed the quality of the underlying carving, revealed the presence of hidden metal fixings and helped establish the authenticity of the original gilding (Fig 4).

Many other samples of the surface coating were taken for cross-section analysis under polarizing microscopy and scanning electron microscopy (SEM). The ordinary cross-section views indicated three layers of gilding (Fig 5).

The initial layer consisted of a red-oxide primer followed by two coats of paint, the first being white and the second a cream colour. A yellow base colour and first gilding were applied and covered with varnish. The original system was covered by a second yellow base coat and gilded. The relatively close layers of the first and second systems were submerged beneath a much thicker white coating, which in turn was covered by a yellow base colour and third gilding, and finished with the application of a final varnish. The samples examined by SEM, with Energy Dispersive X-ray (EDX) analysis, provided information on the elemental composition of the material and showed the significant lead content of the paint layers, as well as calcium carbonate, which probably belonged to a filling material.

In addition to in-house expertise, conservators from other leading institutions were asked to give their opinion on the viability of revealing the original gilded surface. The principal concerns were to establish how much of the first layer had survived, and to find an effective method of removing the over layers. John Anderson from the Tate Gallery and Christine Powell of the Victoria and Albert Museum were invited to carry out inspections. It was concluded that, as the tables had been oil gilded, the use of aggressive solvents would have to be ruled out. Mechanical removal was the only viable alternative. With this in mind, a number of small cleaning tests were carried out by dry stripping the coating with a scalpel. It was found that the top layers were all cleaving at the layer of varnish over the original gilding and that the gold appeared to be intact and in good condition.

With the accumulated data from the various types of analysis, the project team was now able to decide on the course of the conservation programme. In view of the value of the tables and the potentially high cost of conserving them, the team had a responsibility to EH to justify the considerable expenditure that would be incurred. A cost/benefit appraisal procedure was started to assess the conservation costs set against the overall value of the project to the corporate aims of the organization. This was managed admirably by Laura Drysdale, Head of Collections Conservation for EH and the project's team leader, with generous advice and support provided by May Cassar from the Museums and Galleries Commission (MGC). It was decided, among many other considerations, that ensuring the long-term stability of the tables strongly outweighed the other options of non-intervention or gilding over the existing surface. The team resolved to have the additional layers of surface coating removed in order to reveal the original gilding, and make structural repairs. The clear view of the curators was that the tables should be presented in good condition without entirely eliminating areas of natural wear. The application of artificial ageing techniques was to be avoided. These complex decisions were the responsibility of Julius Bryant, EH Director of Collections and Museums, and Treve Rosoman, EH Senior Curator of Furniture, London division. The team relied upon the curators' detailed historical knowledge of Chiswick House and its contents to guide the direction of the tables' conservation and final presentation.

The next stage was to prepare a specification and to invite suitable conservators to tender for the work. The specification document was based on findings of the technical analysis, historical information relating to the tables and guidance on materials and techniques to be used. In addition, further details of insurance requirements, curriculum vitae of the craftspersons to be engaged on the project, health and safety provision and documentation methods were to be included. The tendering procedure was based on a two-envelope system, which entailed the separate evaluation of method from cost. Members of the team would individually mark each tender document, and then convene for a group discussion, out of which a consensus emerged as to the best overall bid.

Five conservation businesses were asked to tender, based on the team's knowledge of their work and reputation. All five inspected the tables on site at Chiswick, and four eventually submitted tenders, with the Tankerdale Workshop emerging as winner. EH could not support the entire cost, so an approach was made to the HLF for further assistance. After careful consideration, very generous help was forthcoming and at last the work could begin.

From the outset it was apparent that a good working relationship between the project team and the contractors would be essential to ensure the successful completion of the project. With this in mind, it was decided that the team would make regular visits to the workshop to monitor progress and to agree any changes that might occur to the original schedule. It was soon realized that the visits would be costly in terms of time and money and that flexibility would be required in order to make them as unobtrusive as possible. Throughout the project, the team came to appreciate the patience and helpfulness with which the Tankerdale conservation staff conducted these visits.

The tables were finally removed from Chiswick House to the Tankerdale Workshop on 30 January 1998.

Figure 6 Detail during conservation showing carved infills in lost areas. © English Heritage

The tops and frames were packed separately in purpose-made cases. A computer data logger was included in the case of one frame, to record temperature and humidity during the journey. Monitoring, the responsibility of Dr Barry Knight, EH environmental specialist, had been going on since the arrival of the tables at Chiswick, and throughout the project this provided important data on fluctuations in the environment that might induce changes in the timber structures.

Work began with making a detailed photographic record of the tables from a number of set angles. These would be repeated throughout the project to compare progress. This record consisted of 35 mm and 50 mm colour transparencies and black and white archival quality prints.

It was also decided that the daily work would be recorded in a logbook. The intention was to produce an objective record of daily progress showing the conservators' solutions to unexpected problems.

Tests began on the dry stripping process, using special hand tools of varying profiles and sharpness. It was soon found that this careful, but tedious, procedure would have to be made more efficient if the work was to be completed on time. After some experimentation, a small electric engraving tool was adapted to vibrate the brittle top layers, and gently bring them away from the original gilding. This method proved to be very effective in revealing large areas, but on some sections it proved less successful. Problems occurred when areas of old damage were exposed, while further losses were the result of

gilding having originally failed to adhere well to the gold size. Other incidental damage was sustained through the stripping method, which was to be expected and is often associated with the procedure. Despite losses, the amount of original gilding revealed justified the continuation of work (see page 2, Fig 1). Carved detail, on the oak-leaf garlands, for example, was beginning to appear from under the heavy surface coating and could be seen in the quality of undercutting and veining. When work on the right-hand table was completed, a dramatic contrast was evident with the table on the left, which still remained largely untouched. The quality and intensity of the uncovered gilding, albeit in damaged condition, confirmed the potential of the completed work. To preserve a record of the pre-conserved coating, the right-side garland of the right-hand table was left unstripped.

Once the dry stripping was completed, repairs to the table frames could begin. Minimum intervention was the guiding principle of all the work done to secure the long-term structural integrity of the frames. All non-original metal brackets supporting broken carving were detached, and breaks were repaired by splicing in replacement timber fillets to realign sections that had moved from their original position. This was particularly important on the left-hand table as the oak-leaf garland to the left of the Triton mask had a marked distortion that disturbed the flow of design. Crude composition repairs were removed and replaced by new carved detail, using stocks of well seasoned eighteenth-century timber of the same species as the original wood (Fig 6).

Loose joints and fractures were fixed with hot animal glue to ensure reversibility for future conservation.

After the structural repairs the (often frustrating) task of reintegrating the damaged gilding was addressed. The left-hand frame had sustained markedly more damage than the other. Obtaining a similar texture to areas surrounding repairs was difficult. Losses were isolated with Paraloid® B72. Over this, layers of pigmented whiting were built up to level the surface. The filling was then worked with scalpels and gouges to achieve the required texture, and water gilded to provide easy reversibility from the surrounding original oil gilding.

Once conservation of the tables had been completed, the project team inspected the work at the Tankerdale Workshop. The finished result had fulfilled all of the requirements of the original specification. The frames looked well balanced and revitalized. To make sure that the final appearance of the repairs was correct, one table was returned to Chiswick on 31 August 1999. This was a fortunate provision – in the prevailing north light of the Gallery many of the water gilded repairs took on a different colour and reflectivity. This unexpected complication meant that an alternative method of gilding the repairs had to be found. Eventually, after some experimentation, it was agreed that the water gilded repairs would be overlaid with oil gilding to obtain the required effect and still maintain reversibility. The tables were returned to the house on 7 October 1999 and the final toning was applied. At last, the Chiswick tables had returned to their rightful place (see page 2, Fig 2).

Conclusion

The completion of the work was the end of a demanding, but ultimately rewarding, project that had achieved the following positive results:

1. Extensive structural repairs had achieved the principal aim of securing the long-term stability of the tables.
2. Uncovering the original gilding has given lightness to the bold design of the carved frames and enhanced the exquisite character of the tops.
3. The final problems associated with integrating the gilding repairs emphasized the important influence of lighting conditions when an object is returned to display after off-site conservation.
4. Understanding of techniques involved in the construction and decoration of early eighteenth-century gilded furniture was increased.
5. New research was carried out on the influence of environmental changes on furniture.
6. The project made a significant contribution to stimulating interest in Chiswick House and the future challenge of conserving and representing its important interiors and furniture.

Acknowledgements

I would like to thank all members of the project team for their assistance in preparing this article and for help with technical information from Graeme Barraclough and Dr Barry Knight of EH. Generous advice and support was also given by John Anderson of the Tate Gallery and Christine Powell of the Victoria and Albert Museum.

Notes

1. Report on the marble tops of the Chiswick House Tables describing types of marble and stone used for decorating tops. Also gives details of design, construction methods and origin of samples.

2. The first detailed report carried out on the tables that identified the conservation issues for the project.

References

Charteris L. 8 October 1996 *Gilding Analysis of Two Side Tables*, Chiswick House, unpublished report, commissioned by English Heritage Conservation Studio.

Williams D. 1997 An Interim Report on the Marble Tops of the Chiswick House Tables, unpublished report, commissioned by English Heritage Conservation Studio.

The Tankerdale Workshop, 26 July 1996 A Condition Report and Proposals for Conservation Treatment, unpublished report, commissioned by English Heritage Conservation Studio.

Materials and equipment
Table frames
Adhesive:
Hot-melt animal glue for attachment of replacement carving and re-gluing of loose components.
Softening of old adhesive residues:
Distilled water and Laponite RD (MS) synthetic inorganic colloid.
Laponite RD:
Conservation Resources (UK) Ltd, Units 1, 2 and 4 Pony Road, Horspath Industrial Estate, Cowley, Oxford OX4 2RP. tel: 01865 747755
Removal of built-up over-layers
Scalpels, spatulas and a Burgess Vibro-Graver model V-74 electric hand tool with various customised bits (Vibro-Graver tool supplied by Frank W. Joel Ltd, Kings Lynn, Norfolk, no longer trading).
Replacement timber:
Tankerdale Workshop stocks of reclaimed eighteenth-century pine for repairing broken pieces of carving and the replacement of missing sections.
Filling
Fine texture putty made from whiting and fish glue with compressive micro glass balloons to accomodate movement.
Fish glue:
Lee Valley Tools Ltd, 1080 Morrison Drive, Ottawa, Ontario K2H 8K7, Canada
Micro balloons:
Strand of the Scotts Bader Group, Wessex Resins & Adhesives Ltd, Cupernham, Cupernham Lane, Romsey, Hampshire SO51 7LF. tel: 01794 521111

Isolation of damaged areas prior to further treatment
Paraloid B72:
Conservation Resources (UK) Ltd (address given above)
Gilding
23 carat Italian gold leaf for gilding repairs:
L. Cornelissen and Son Ltd, 105 Great Russell Street,
London WC1B 3RY. tel: 0207 636 1045
fax: 0207 636 3655

Table tops
Surface cleaned with a mixture of 1:1 de-ionised water
and white spirit with 1-2 drops of Synperonic N
(Nonylphenol Ethoxylate used as a non-ionic deter-
gent). Since 2000 the use of Synperonic N (NPEs) has
been banned.
Following cleaning and air drying of the surfaces
microcrystalline wax was applied and polished to an
appropriate level.
Microcrystalline wax:
Conservation Resources (UK) Ltd (address given above)

Biography
Dave Gribbin studied Fine Art at Sunderland
Polytechnic from 1974–78. He joined the Tate Gallery
in 1979 and worked as a technician in the Conservation
Department. Since 1986 he has broadened his experi-
ence with English Heritage as a conservator at the
Conservation Studio.

Index